TO

FROM

DATE

AMAZING GRACE

Amazing Grace Coloring Book
Copyright © 2016 by Zondervan

Requests for information should be addressed to:
Zondervan, 3900 Sparks Dr., SE, Grand Rapids, MI 49546

ISBN 978-0-310-34707-1

Any Internet addresses (websites, blogs, etc.) and telephone numbers in this book are offered as a resource. They are not intended in any way to be or imply an endorsement by Zondervan, nor does Zondervan vouch for the content of these sites and numbers for the life of this book.

Cover photography or illustration: Suzanne Khushi
Interior illustration: Suzanne Khushi
Interior design: Lori Lynch

Printed in the United States

16 17 18 19 20 21 22 23 /RRD/ 38 37 36 35 34 33 32 31 30 29 28 27 26 25 24 23 22 21 20 19 18 17 16 15 14 13 12 11 10 9 8 7 6 5 4

AMAZING GRACE
Coloring Book

ZONDERVAN®

Share your masterpiece using
#WorshipInColor and #AdultColoringBook

Amazing
GRACE!

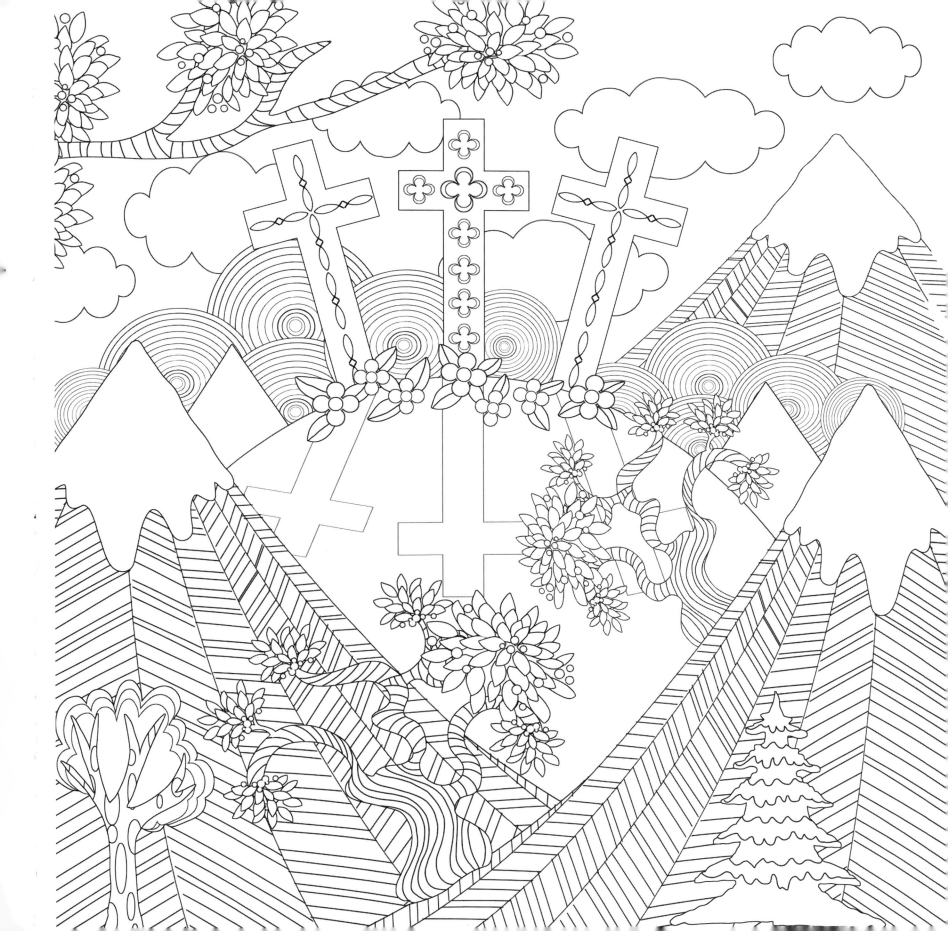

HOW
sweet
THE SOUND

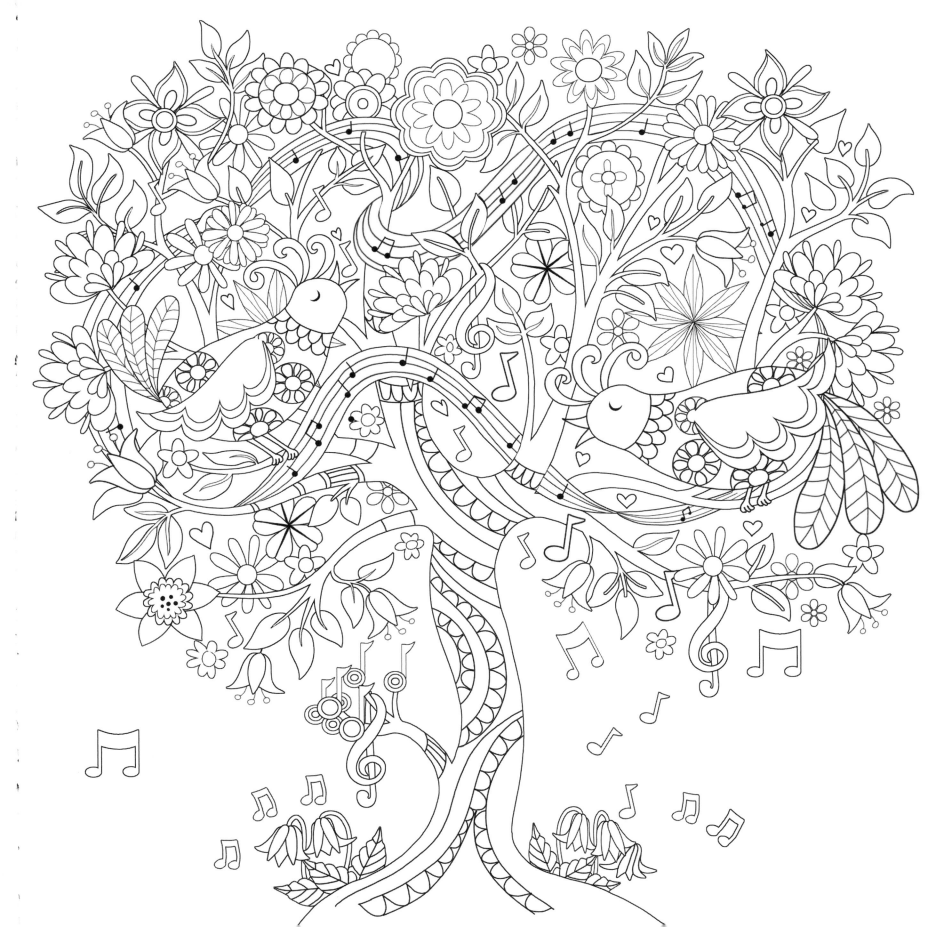

That saved
a wretch
like me!

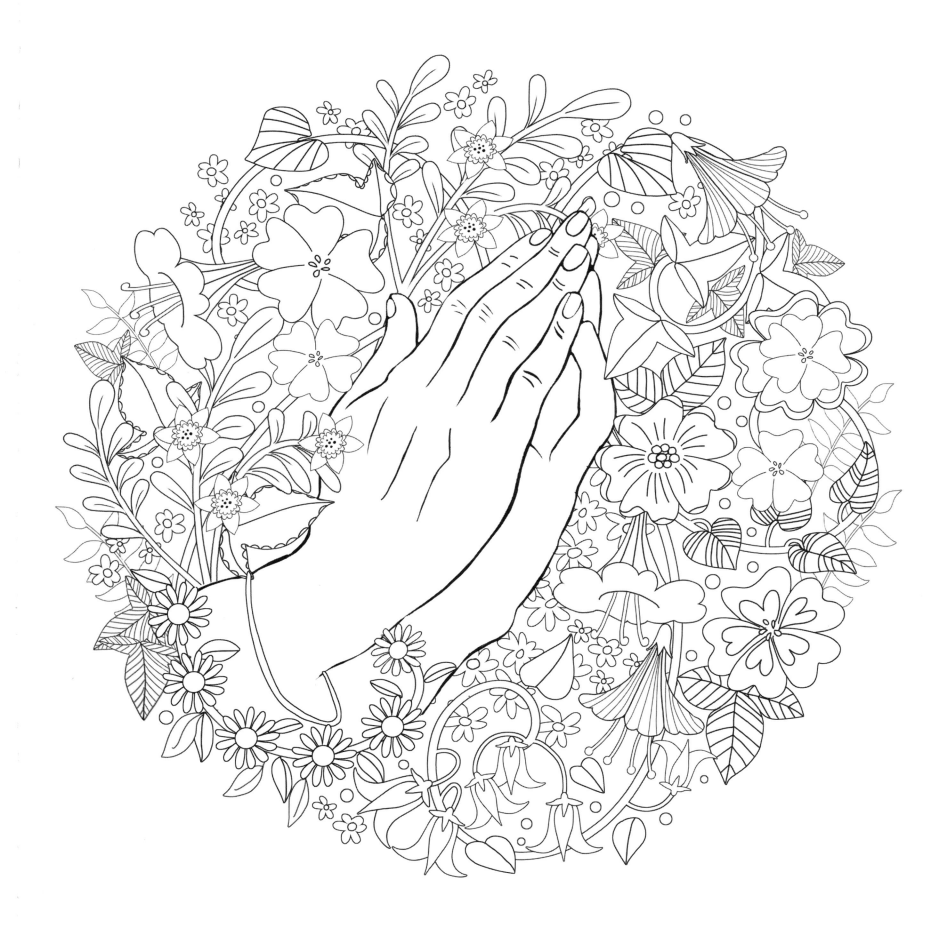

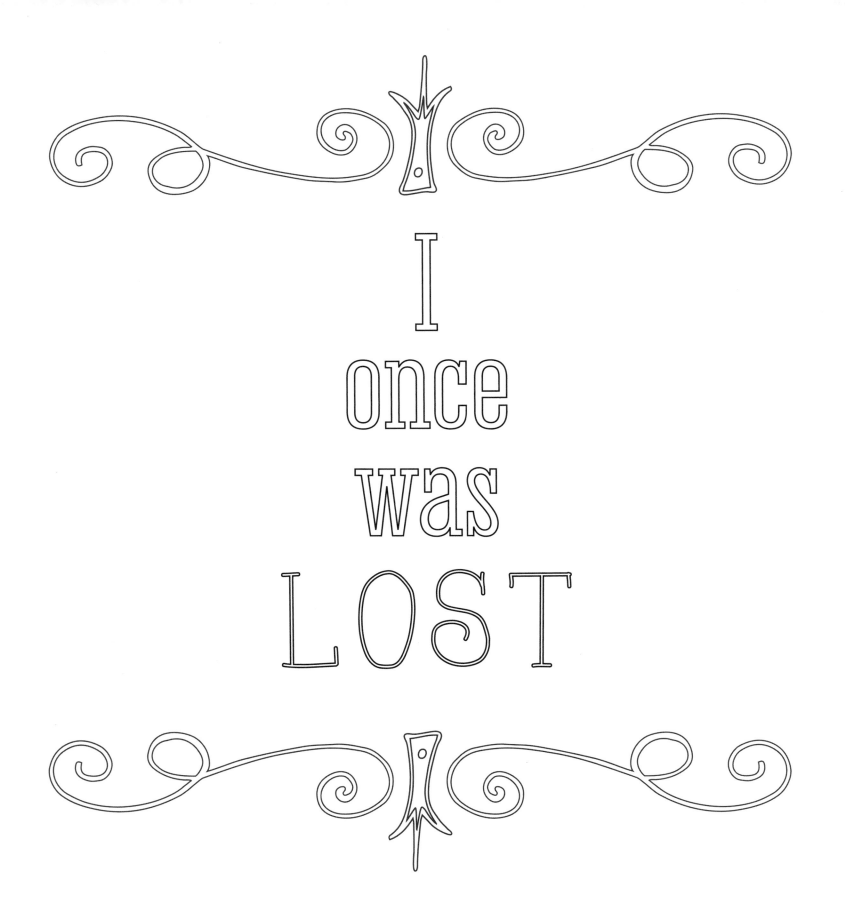

I
once
was
LOST

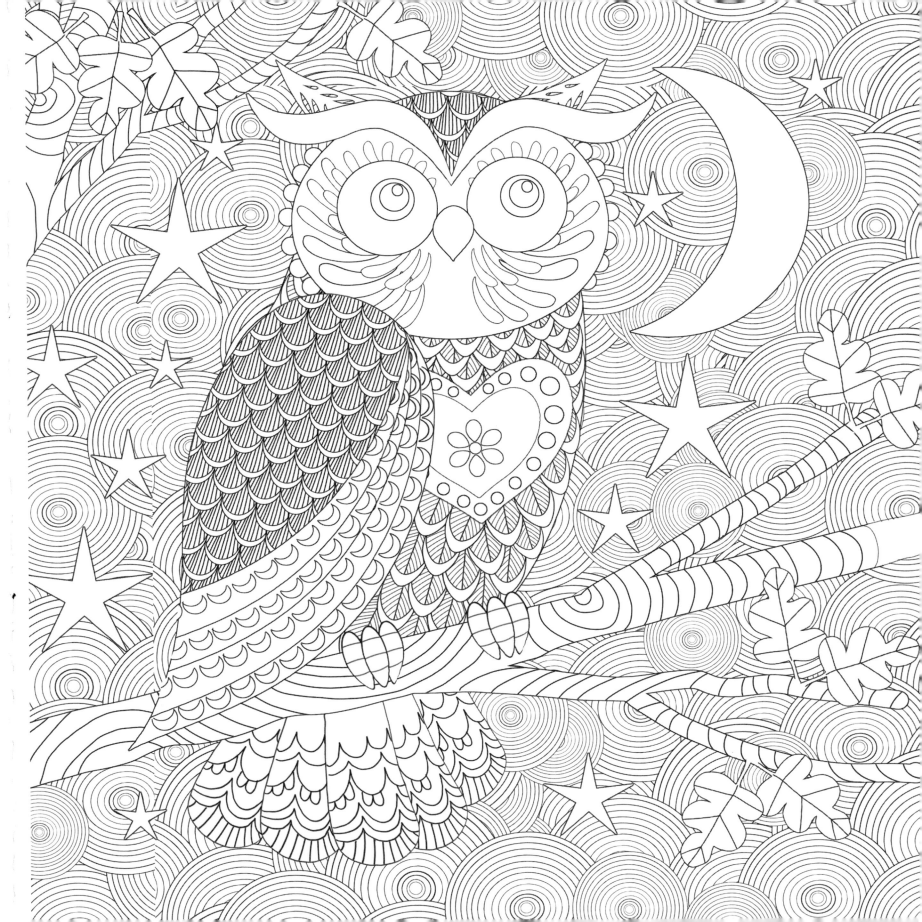

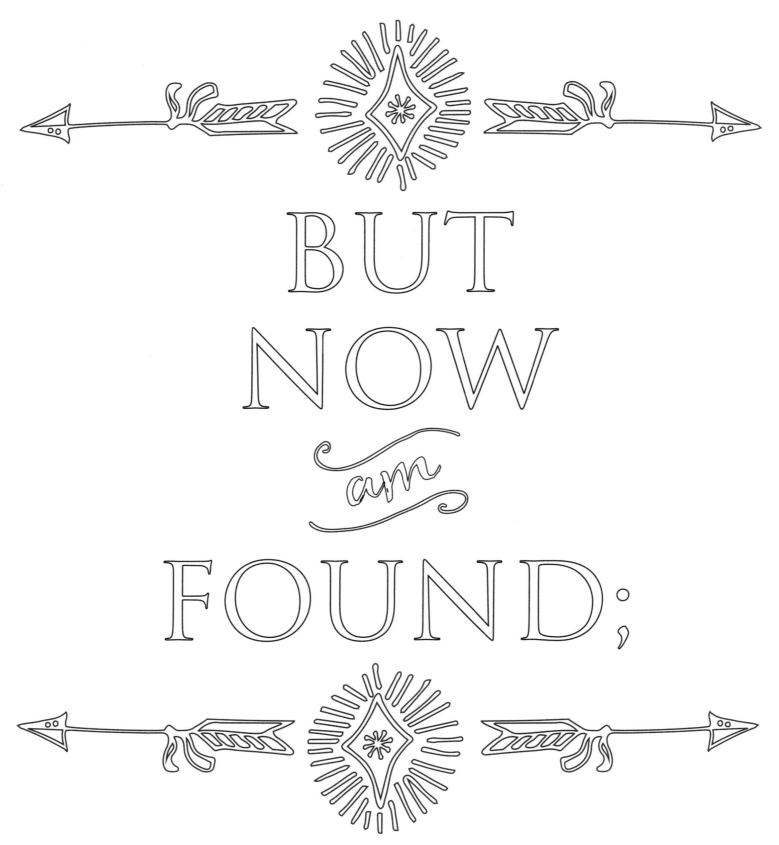

BUT NOW *am* FOUND;

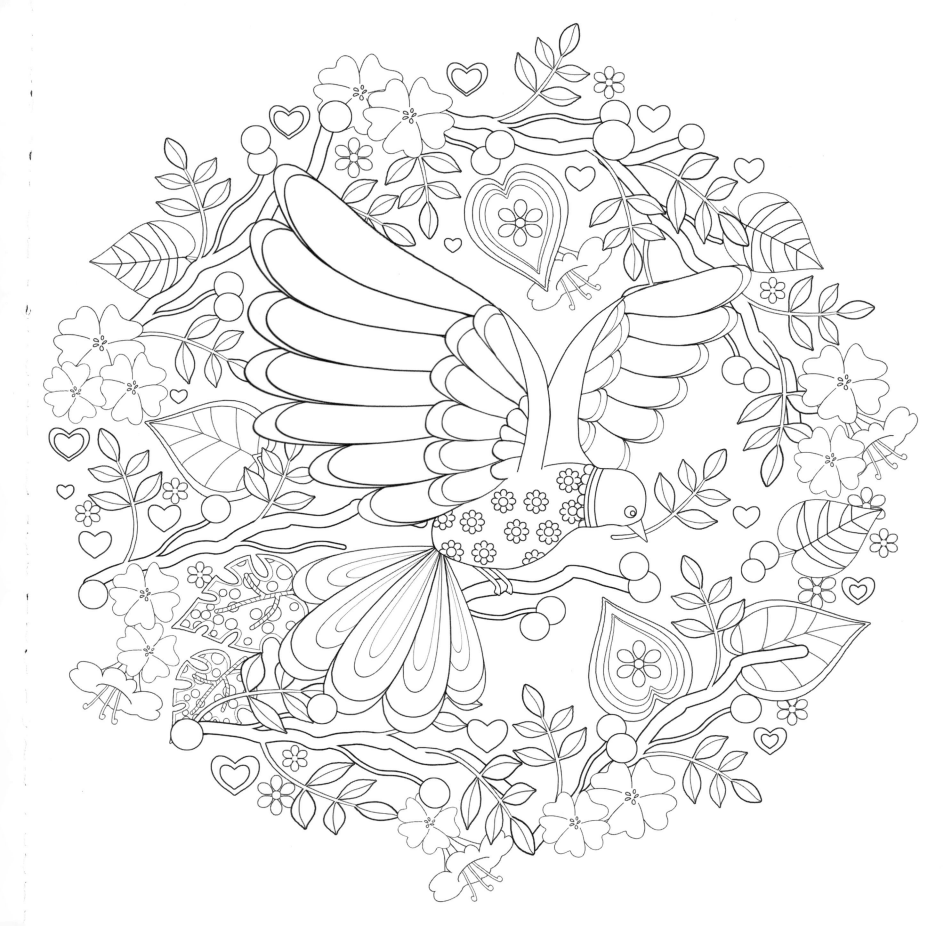

Was blind, BUT NOW I see.

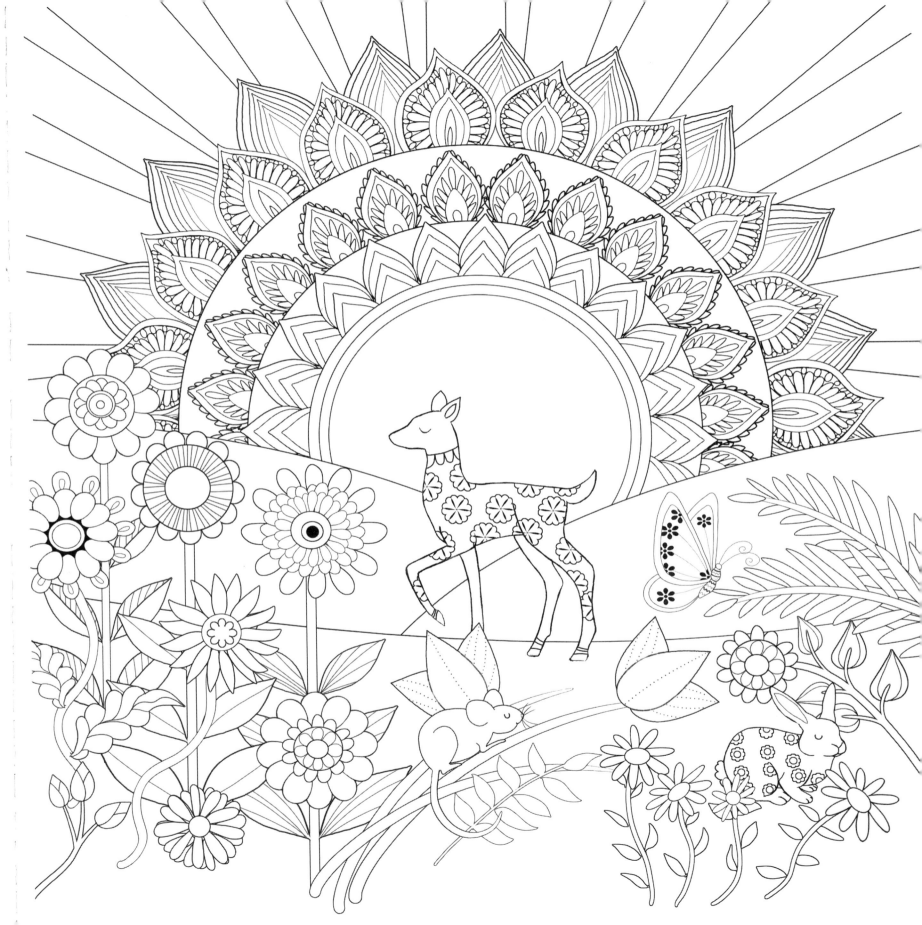

'Twas
grace
that
taught

my

heart

TO FEAR,

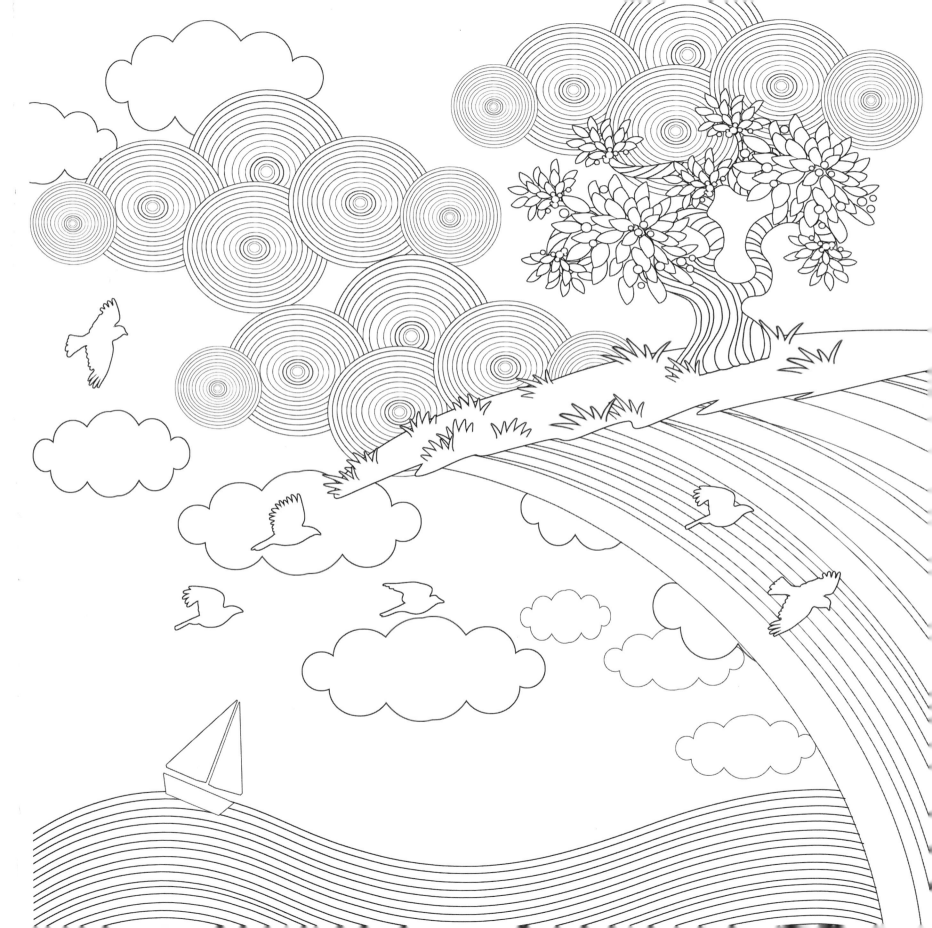

And
GRACE
my fears
relieved;

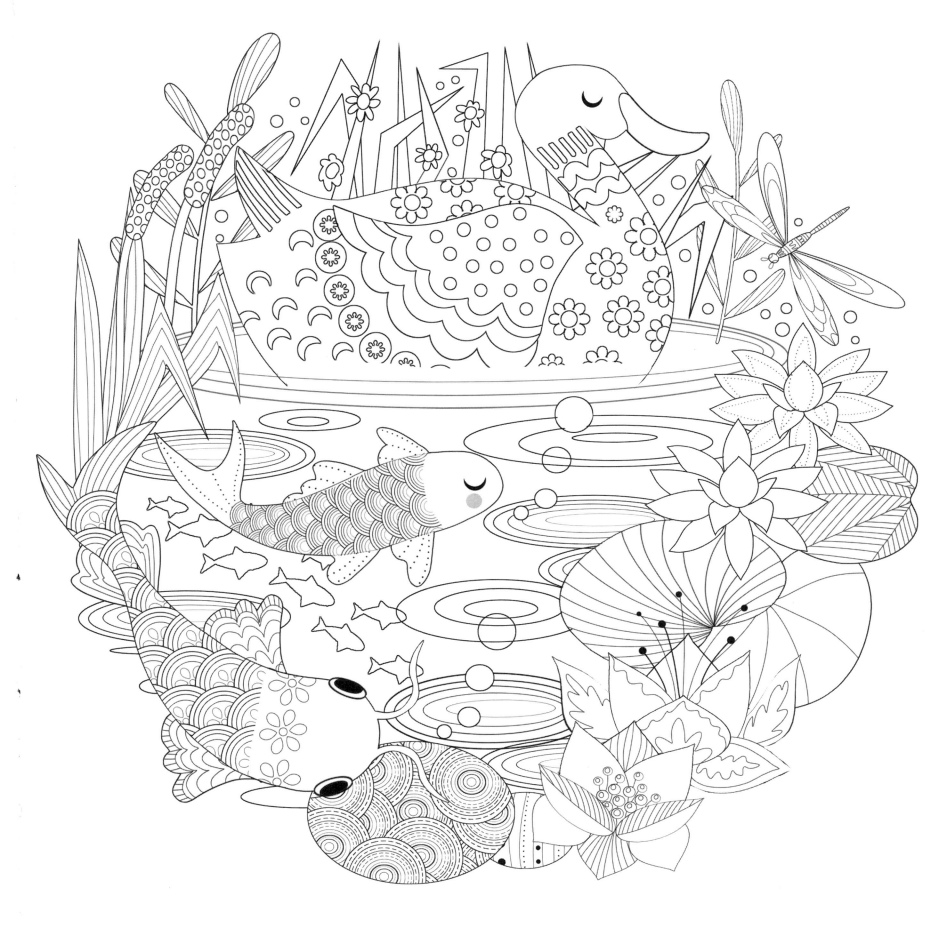

How precious did

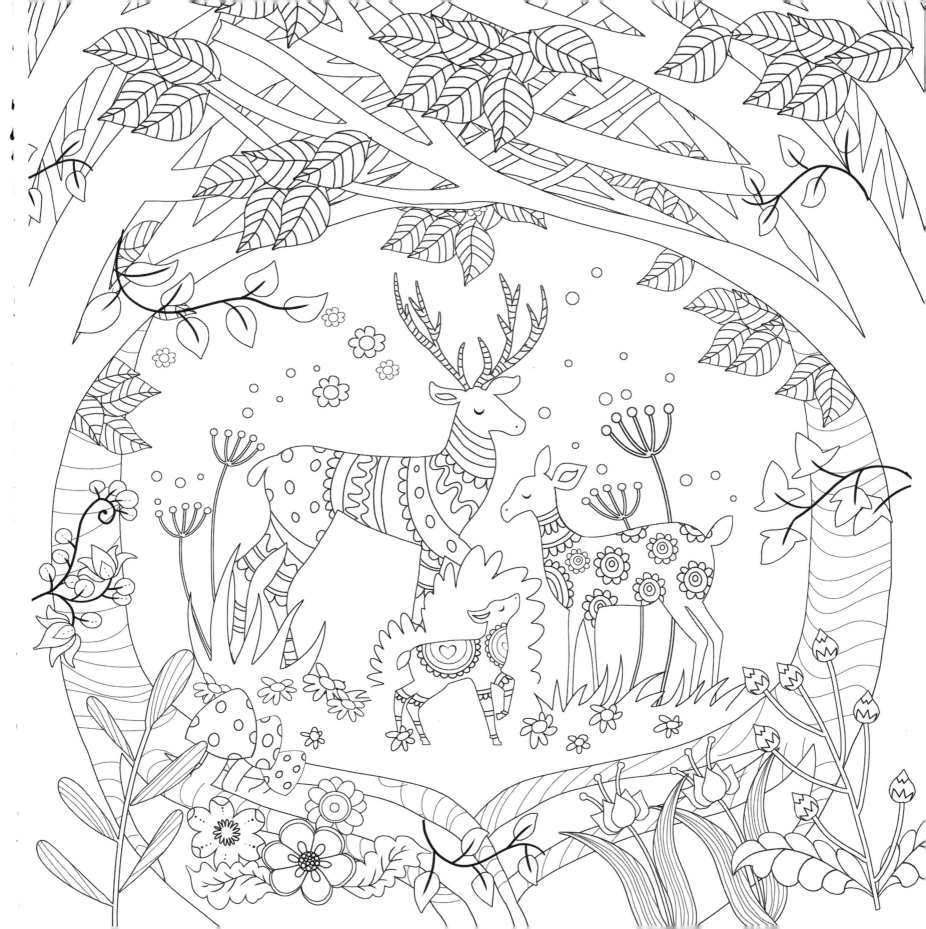

that
GRACE
APPEAR

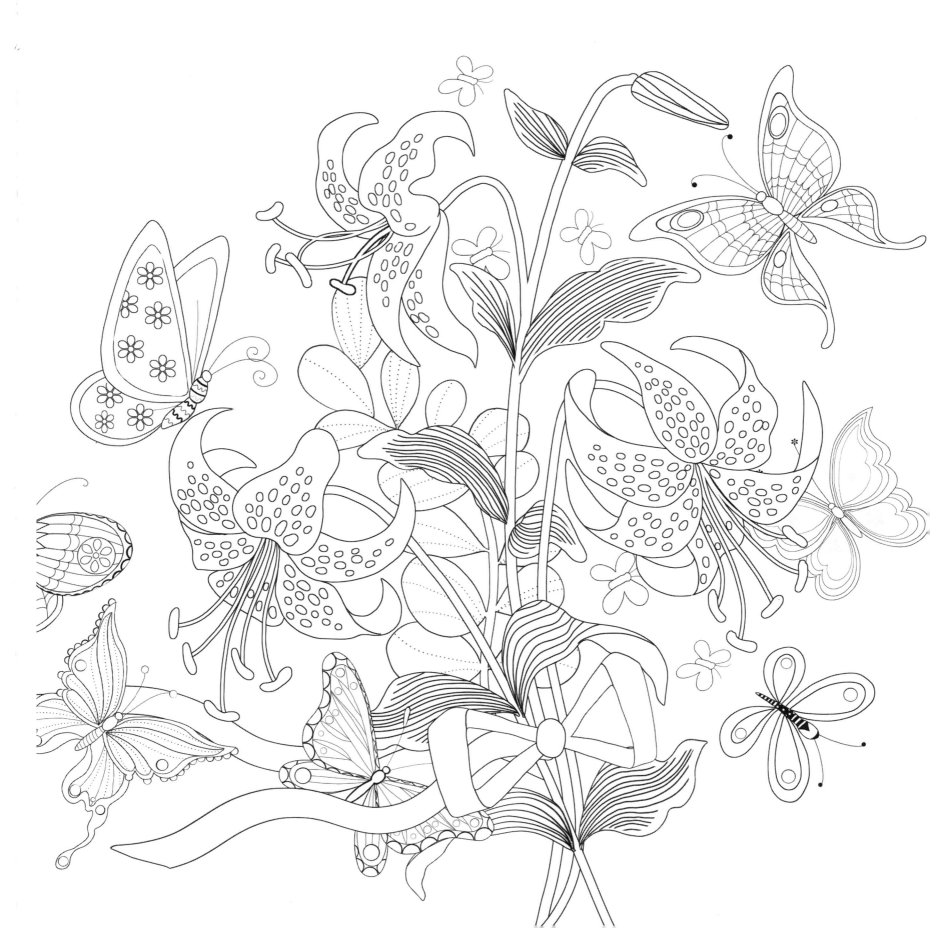

The hour
I first
believed!

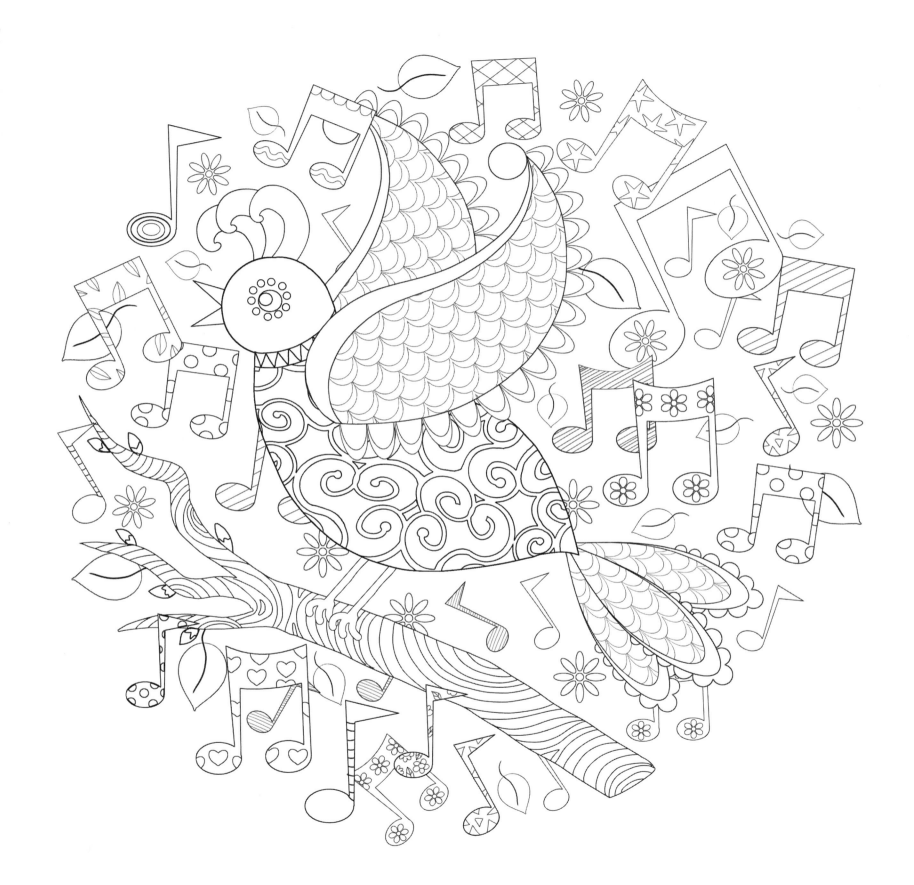

Through
MANY
dangers,

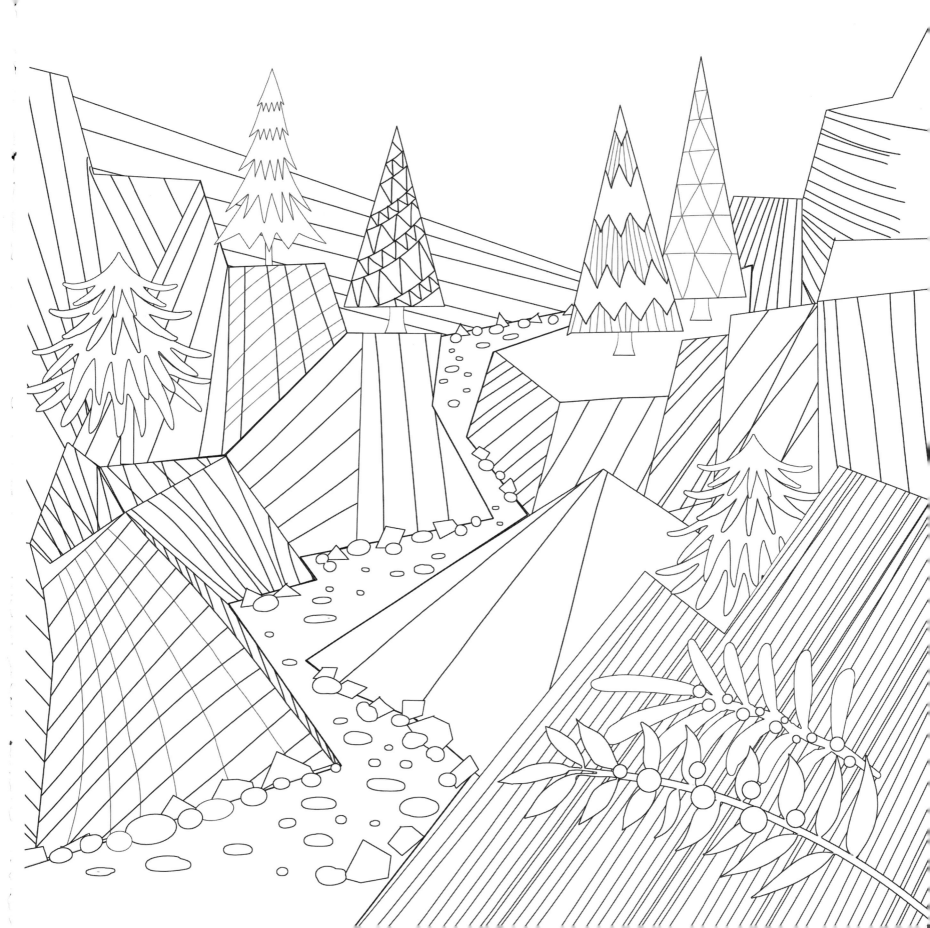

tols and and SNARES,

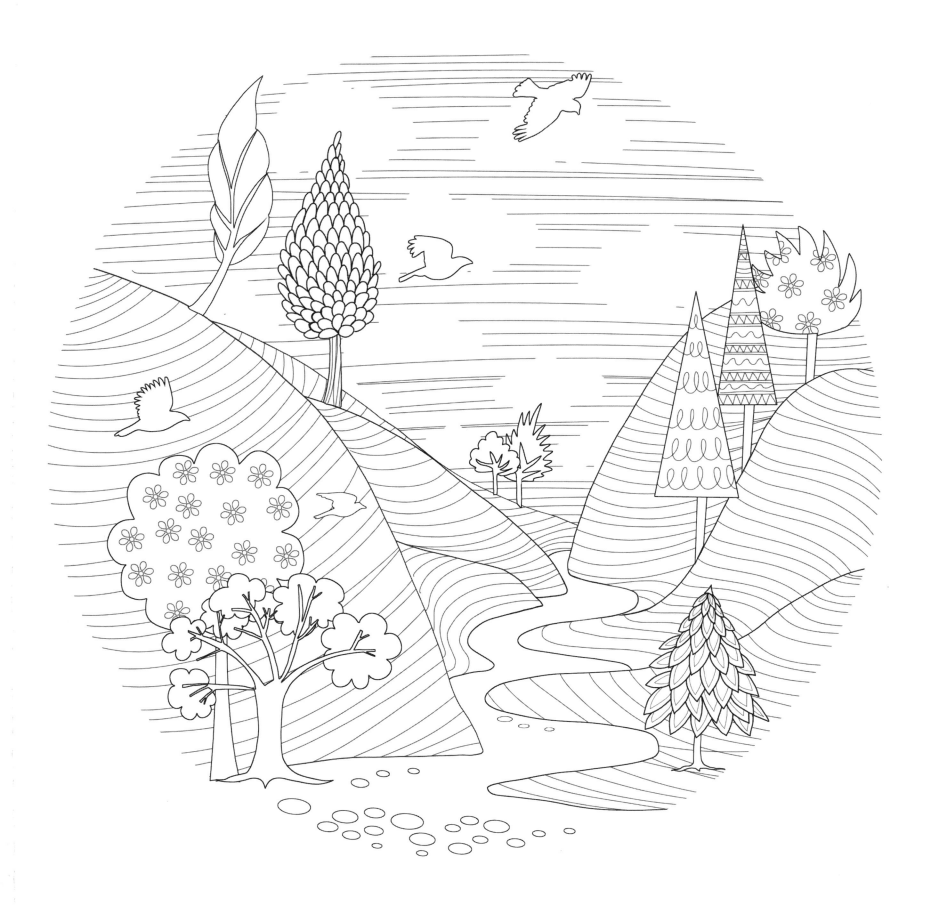

'Tis
GRACE
hath
BROUGht
me

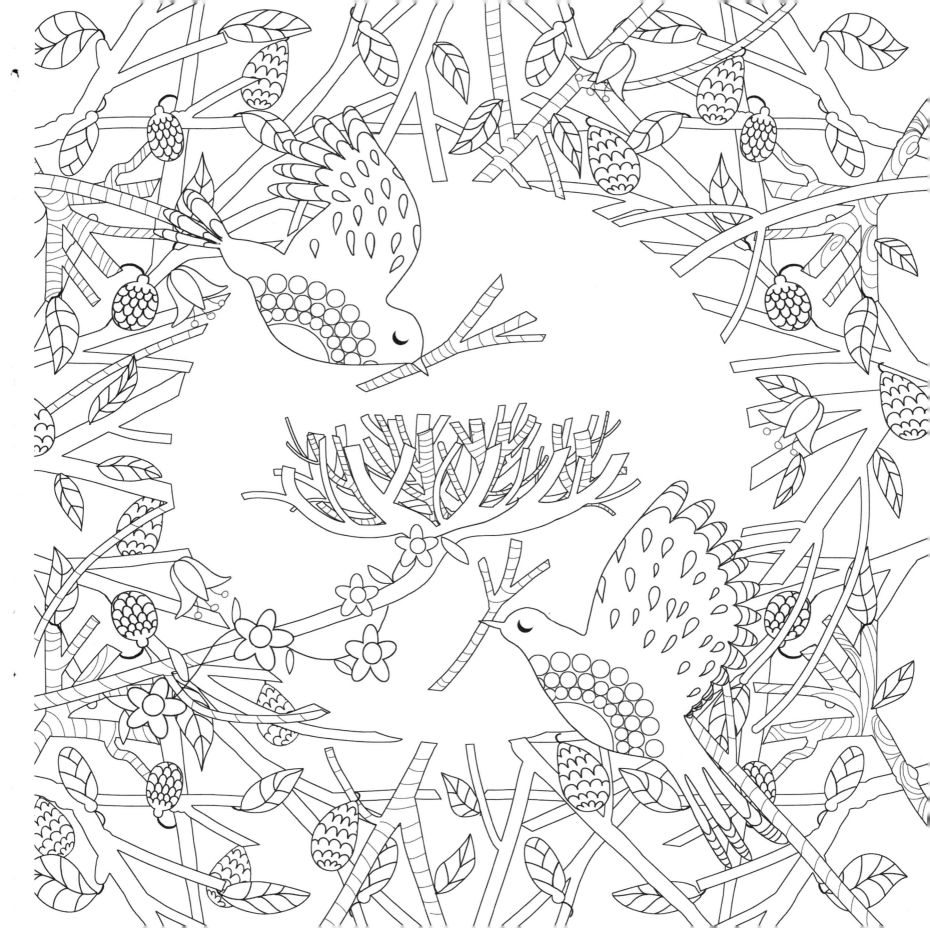

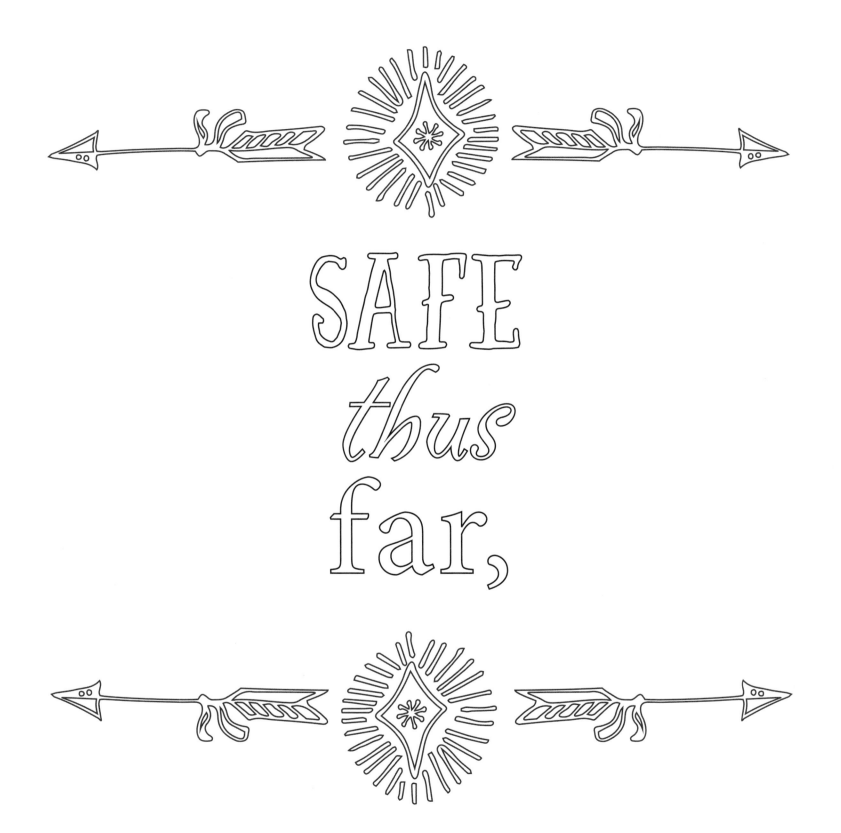

SAFE *thus* far,

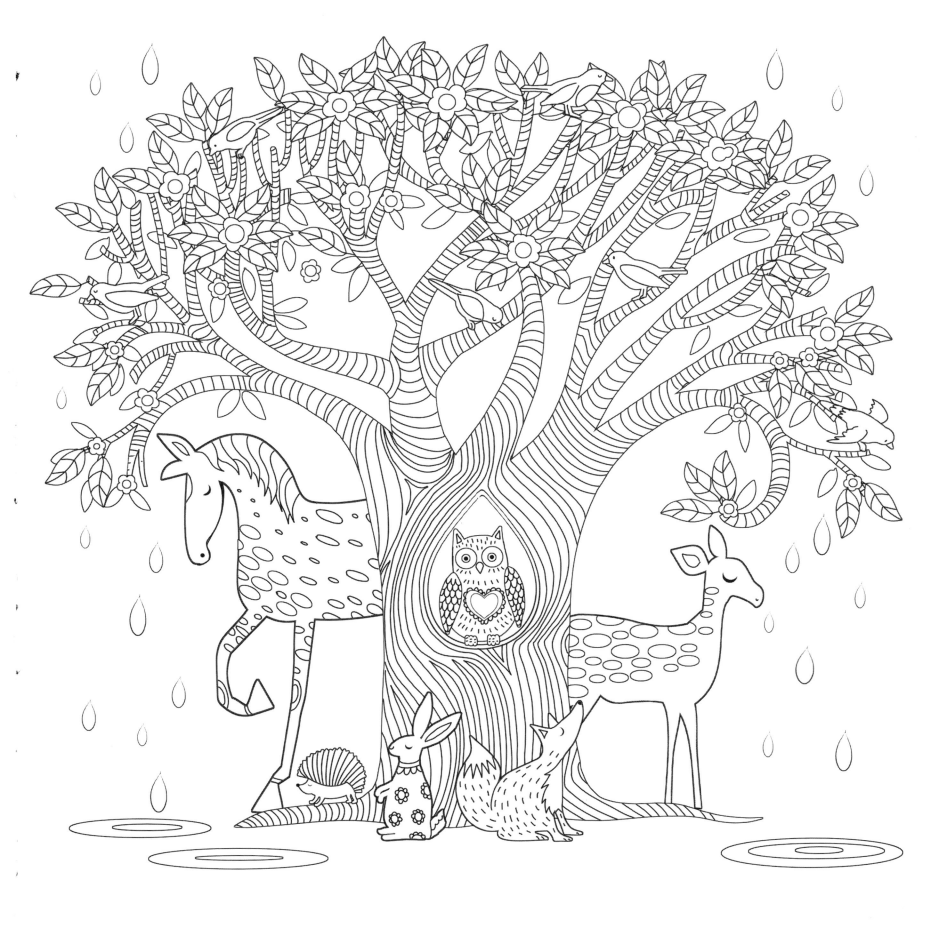

And

GRACE

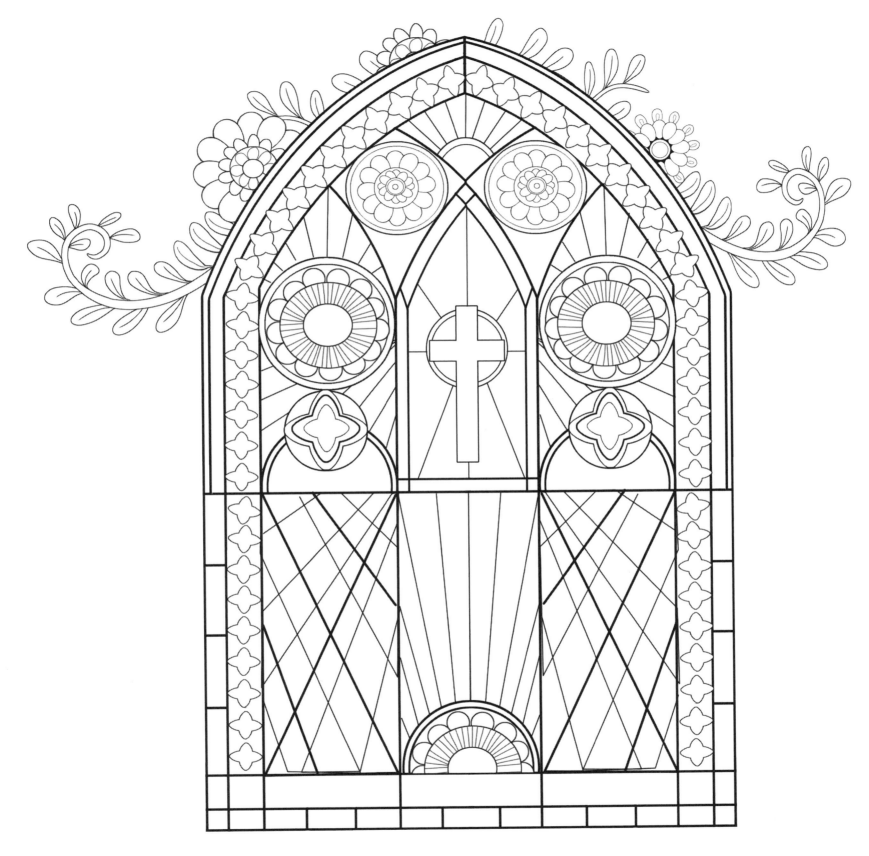

WILL LEAD
me
home.

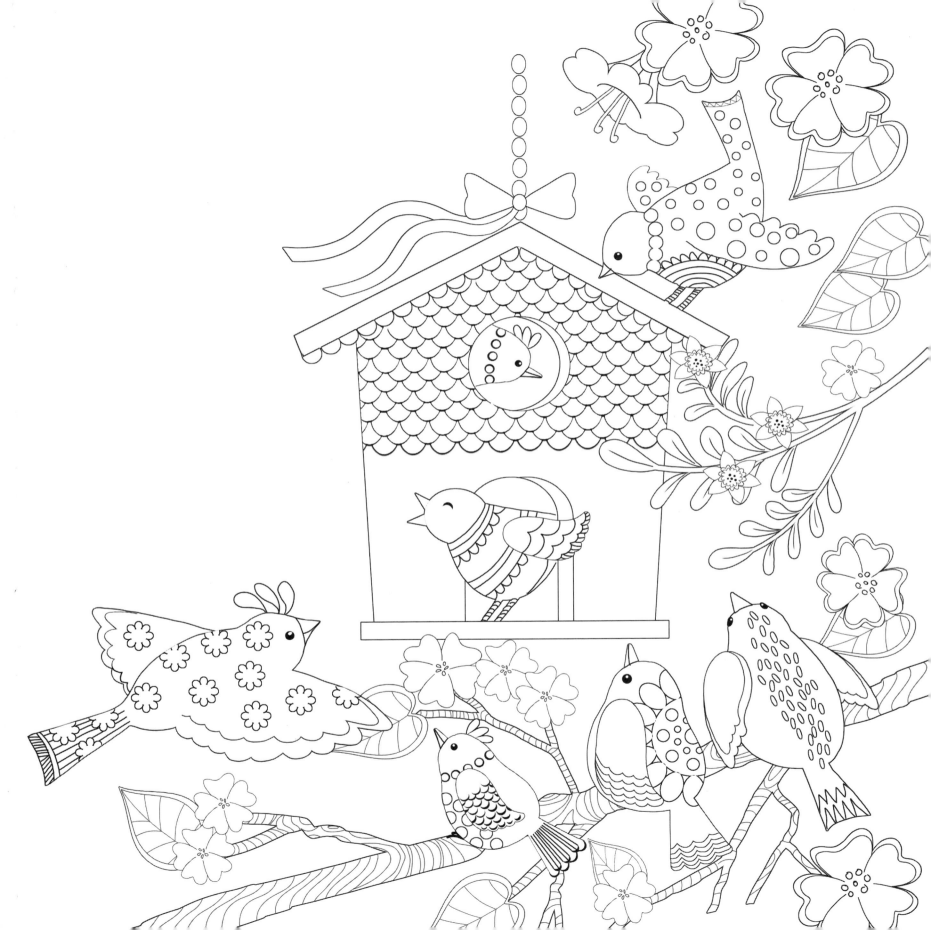

The
Lord
has
PROMISED

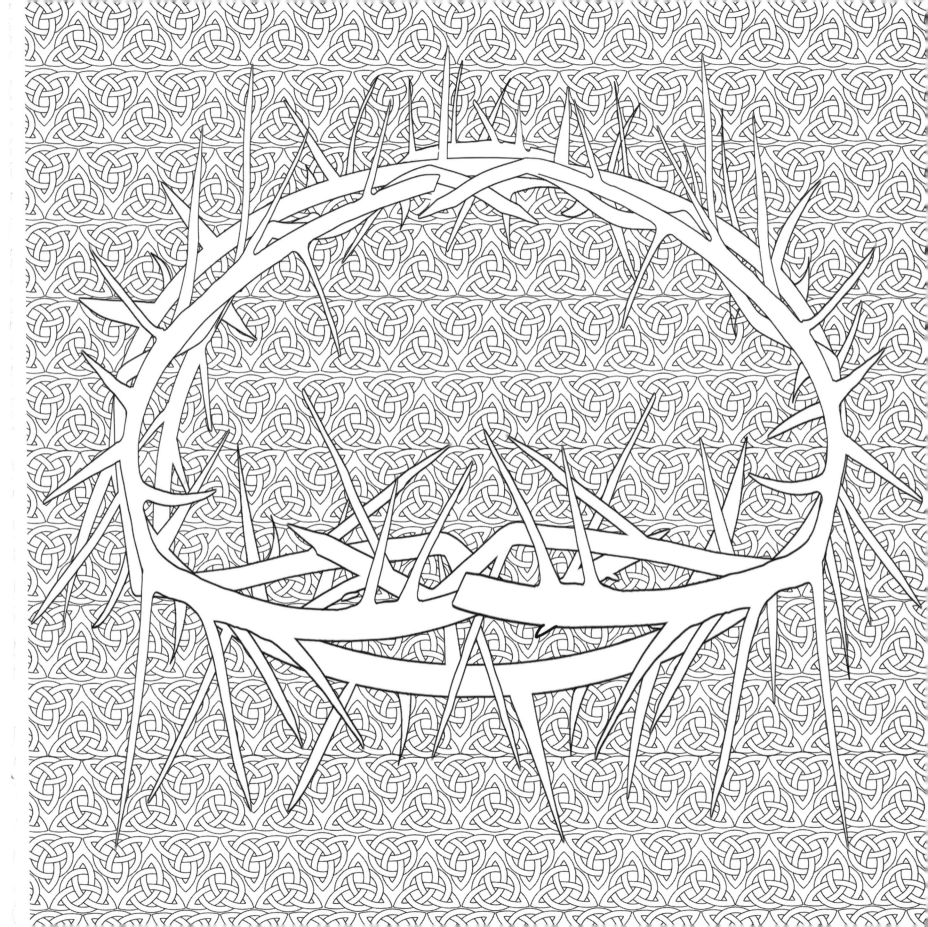

good to me,

HIS
Word

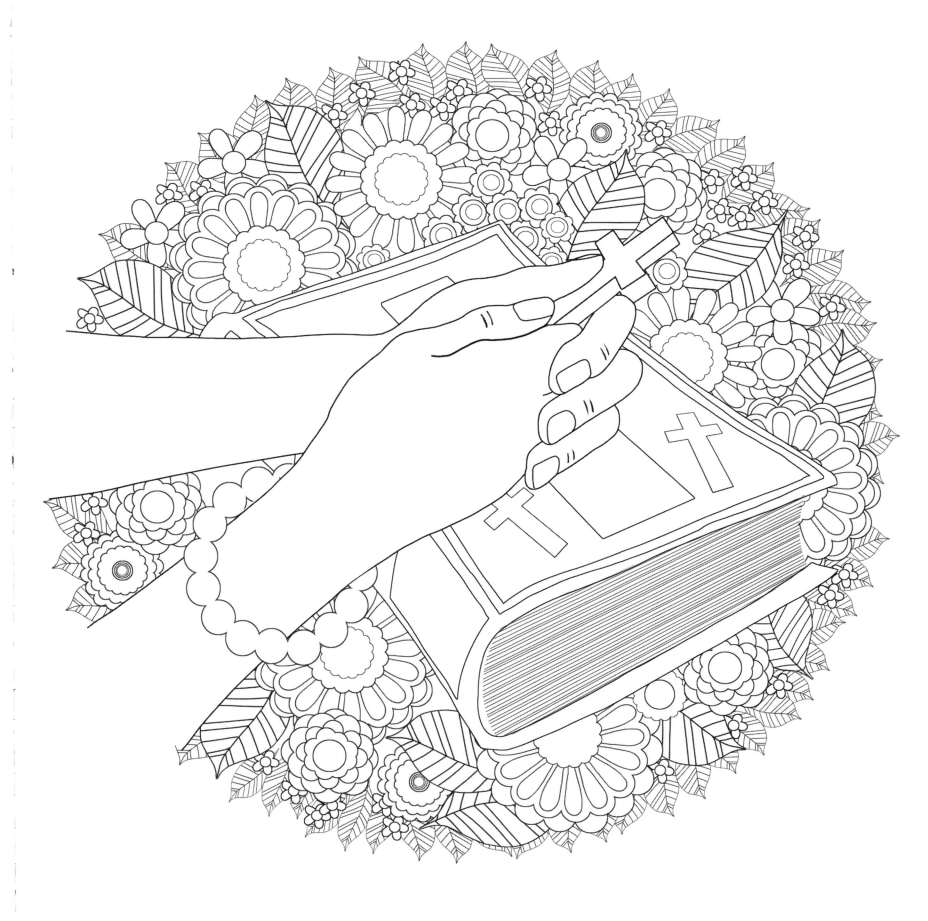

MY
HOPE
secures;

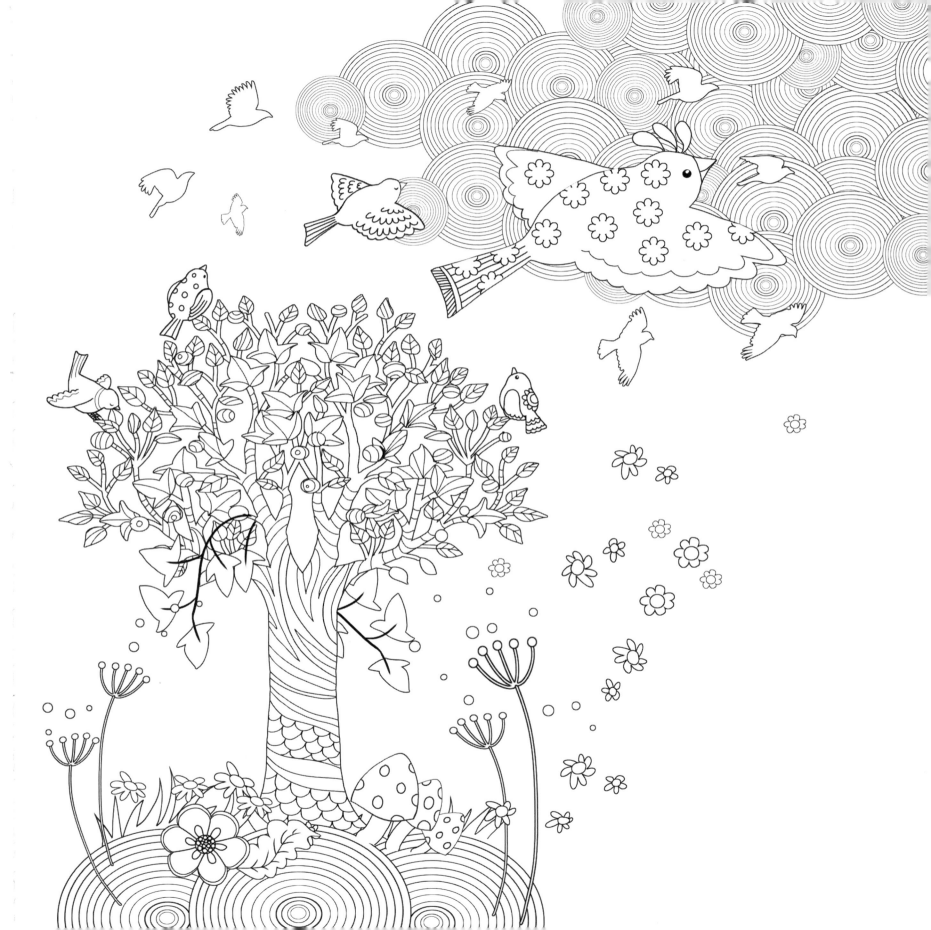

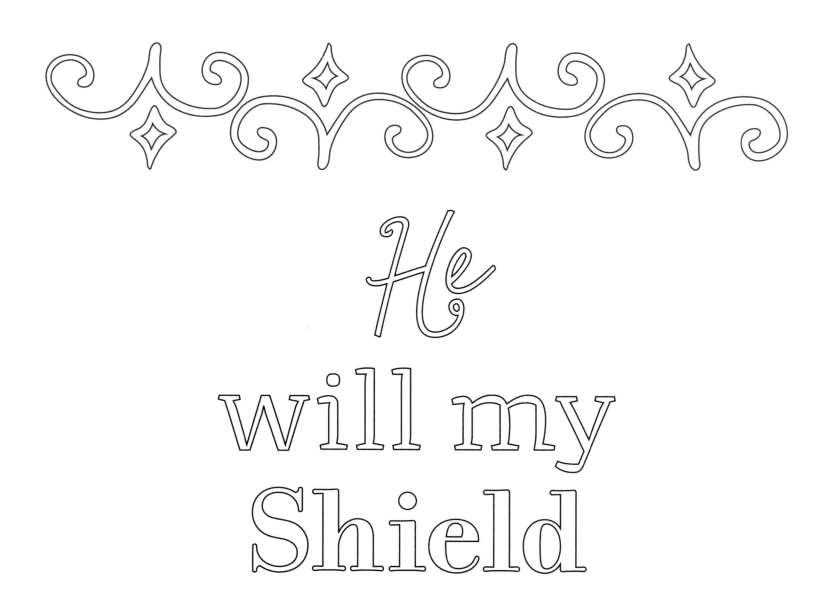

He
will my
Shield

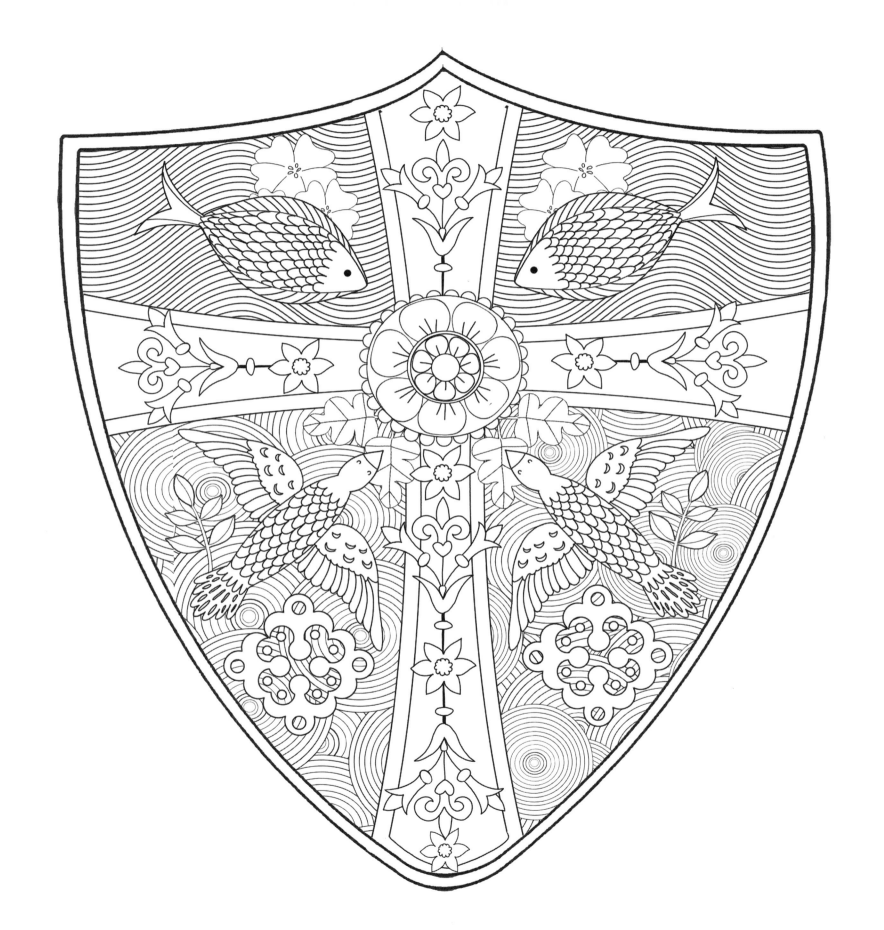

AND PORTION BE,

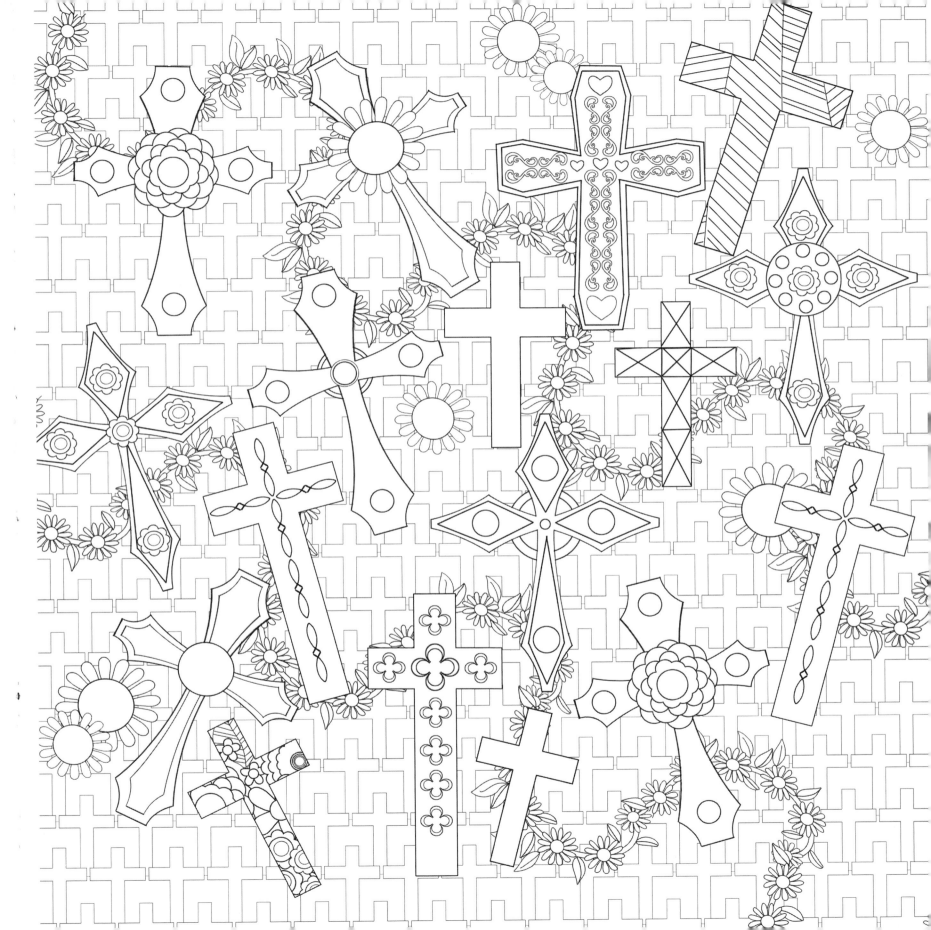

As long as life endures.

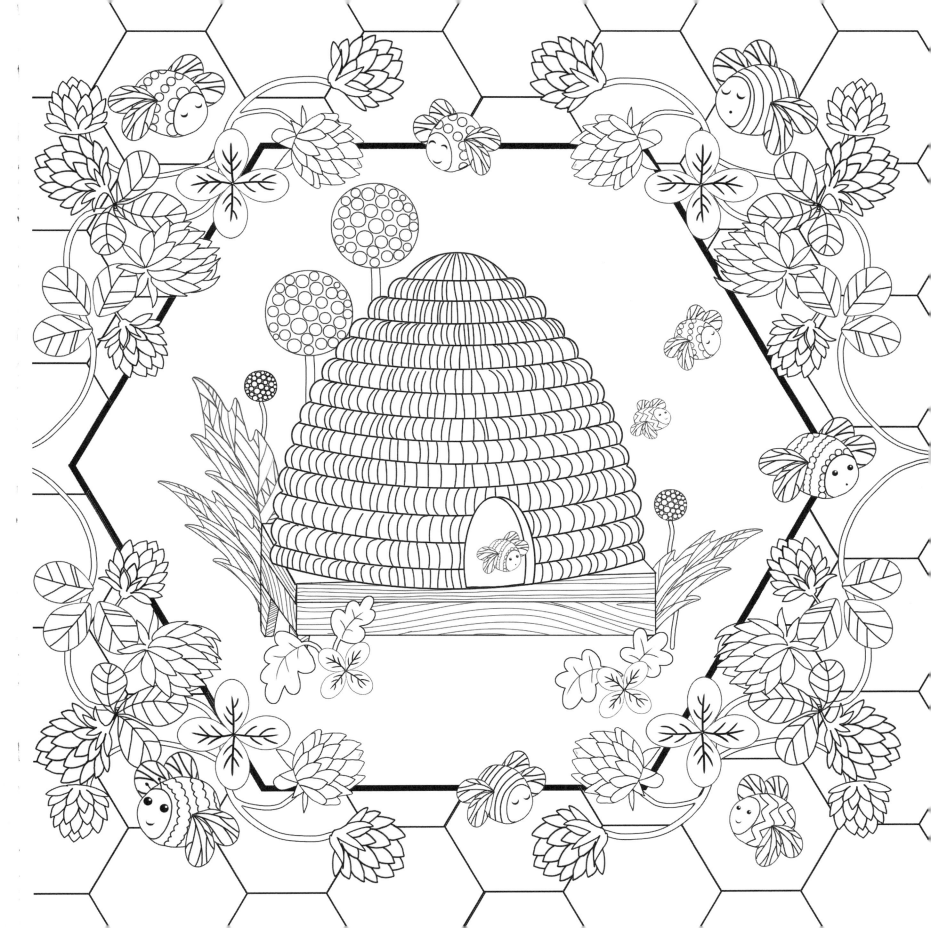

Yea, when this flesh

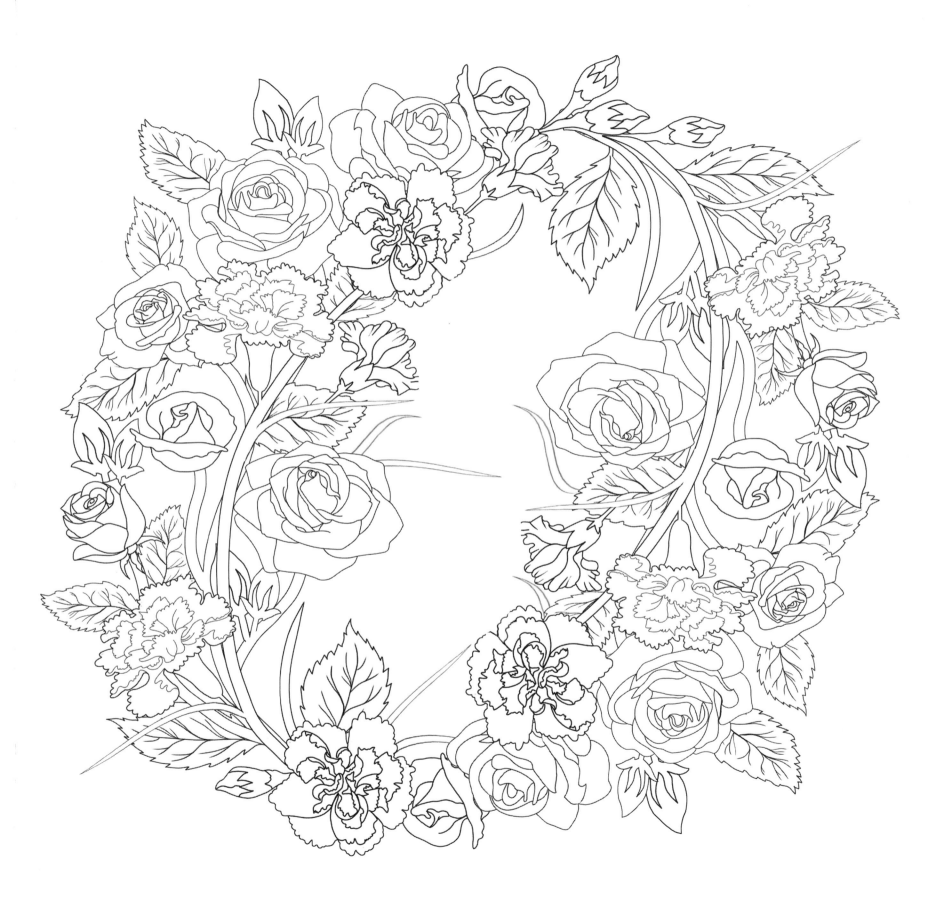

AND
heart shall
FAIL,

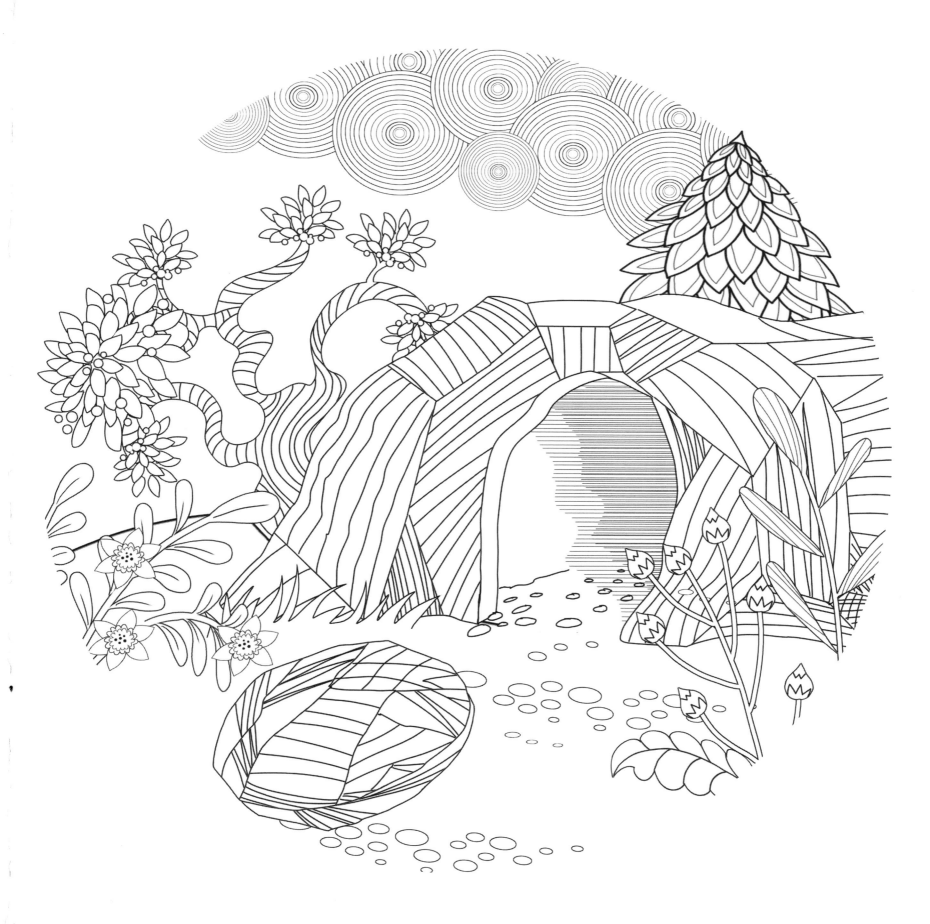

And mortal life shall CEASE,

I
shall
possess,

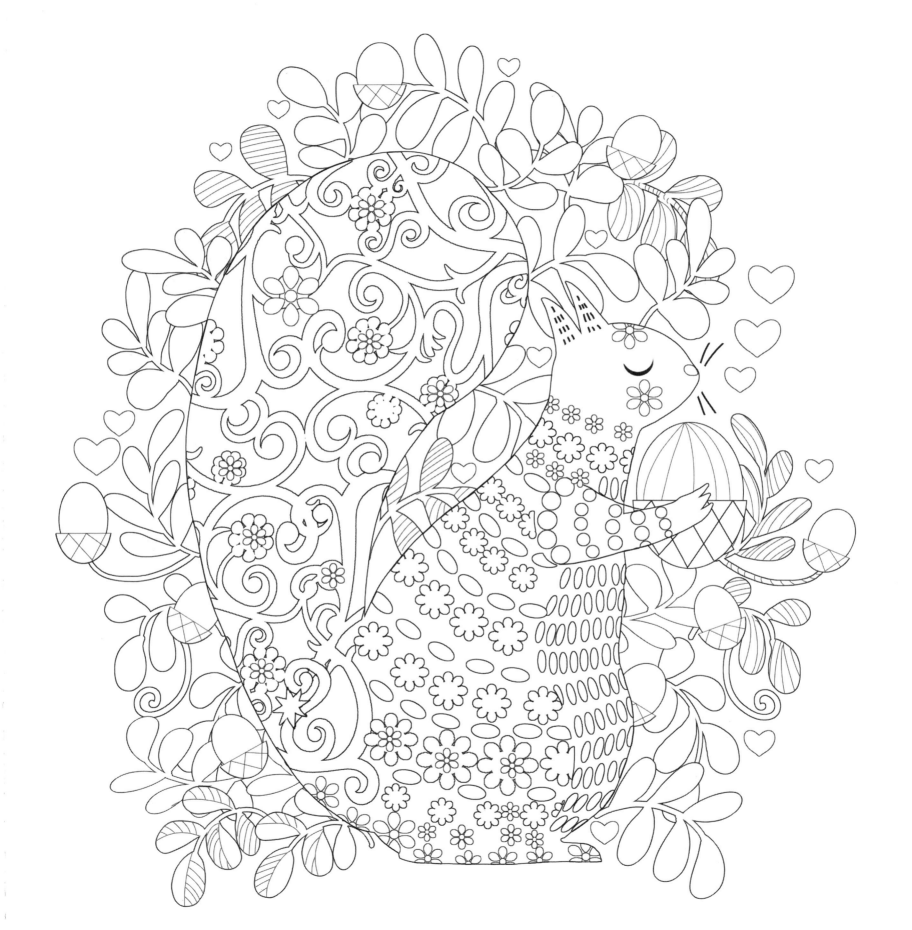

A life
of joy and
peace.

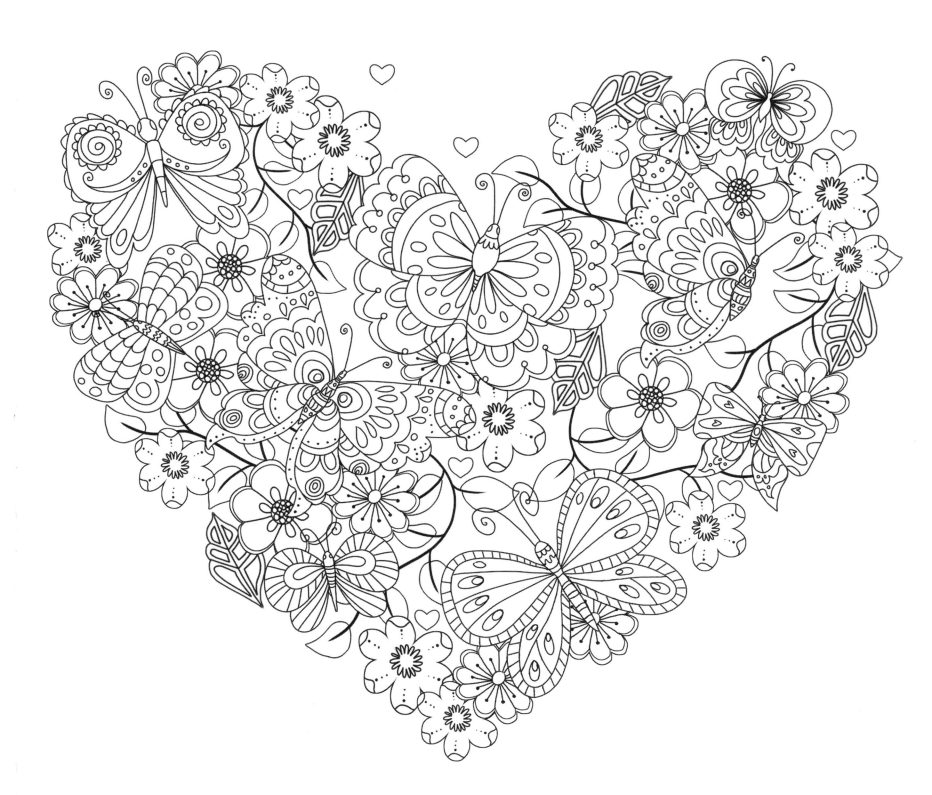

the
EARTH
shall soon

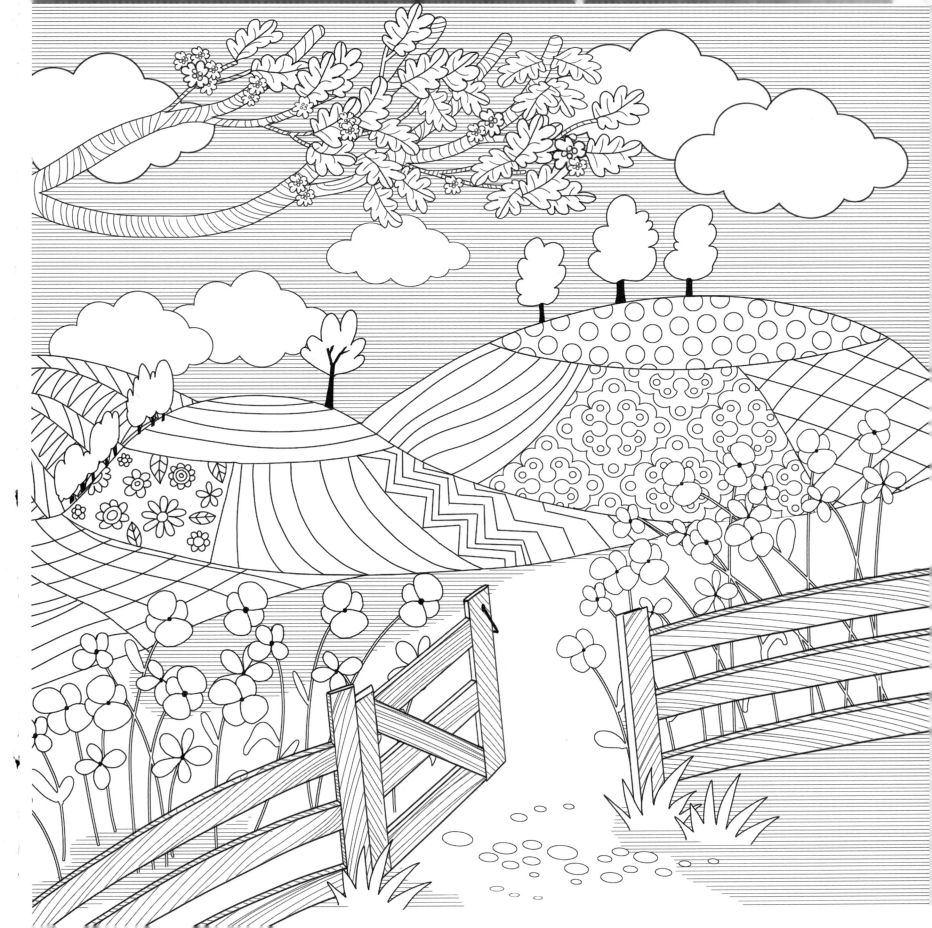

dissolve like snow,

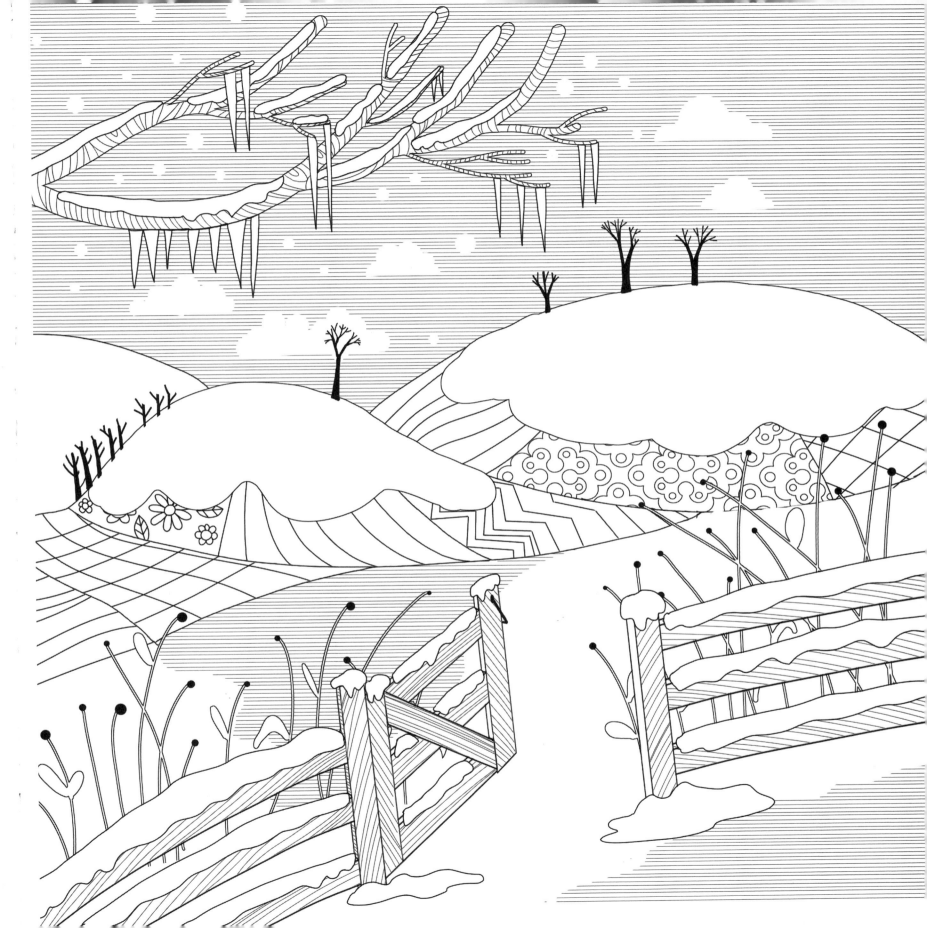

The
SUN
forbear to
SHINE;

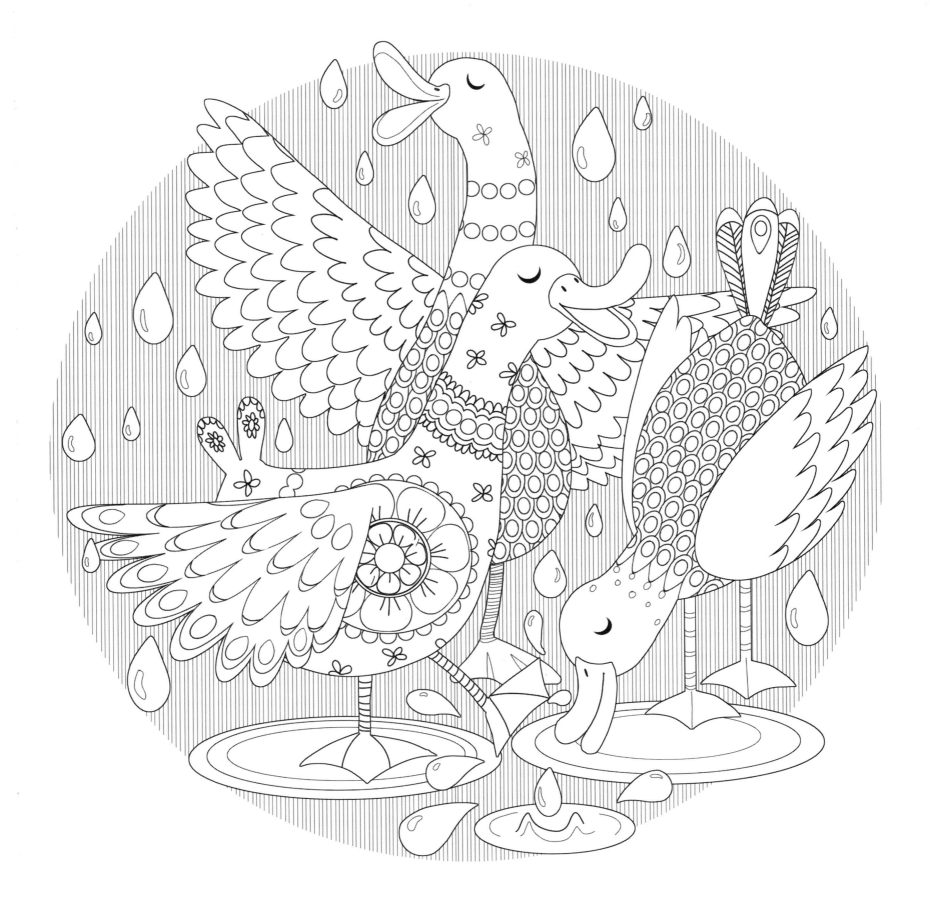

BUT
God,

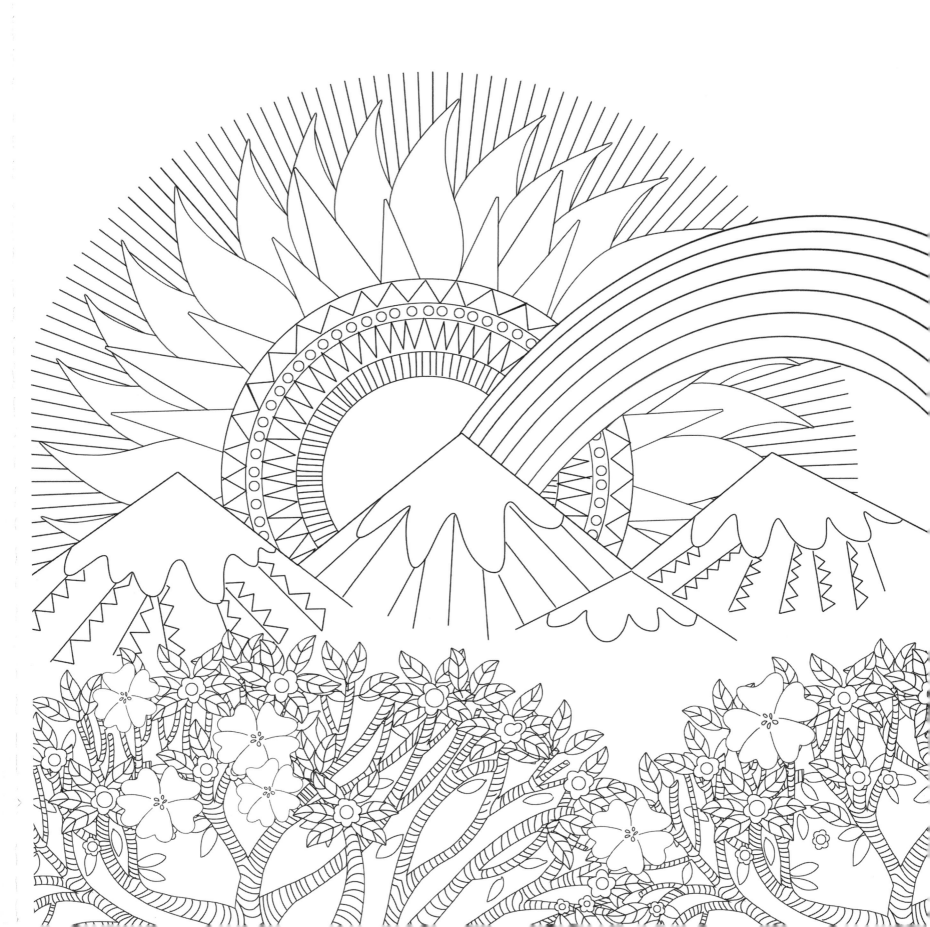

who
called
me here
below,

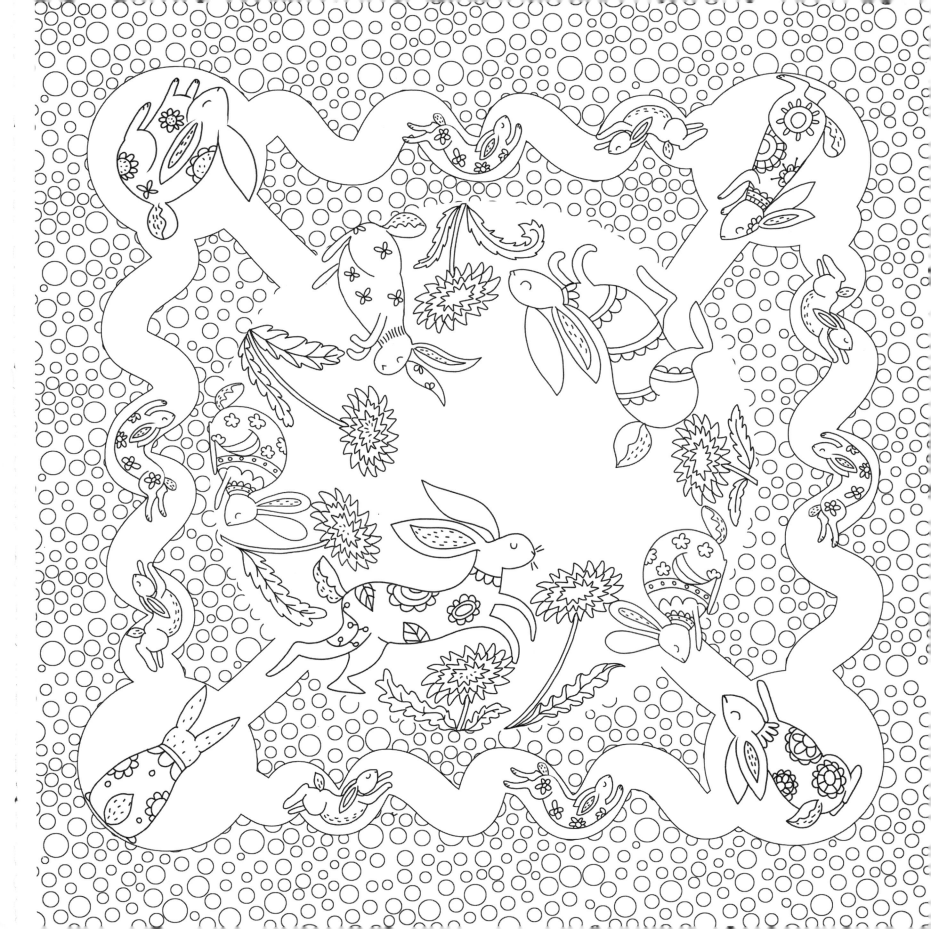

will be
forever
mine.

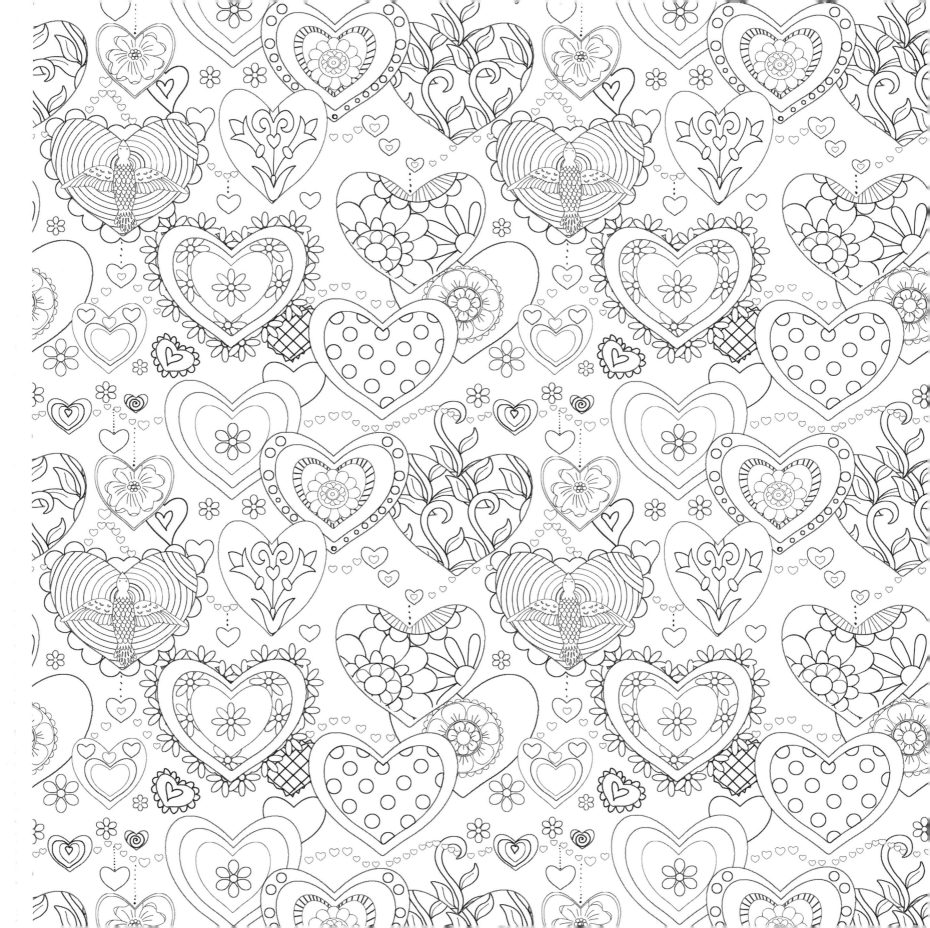

ten thousand years,

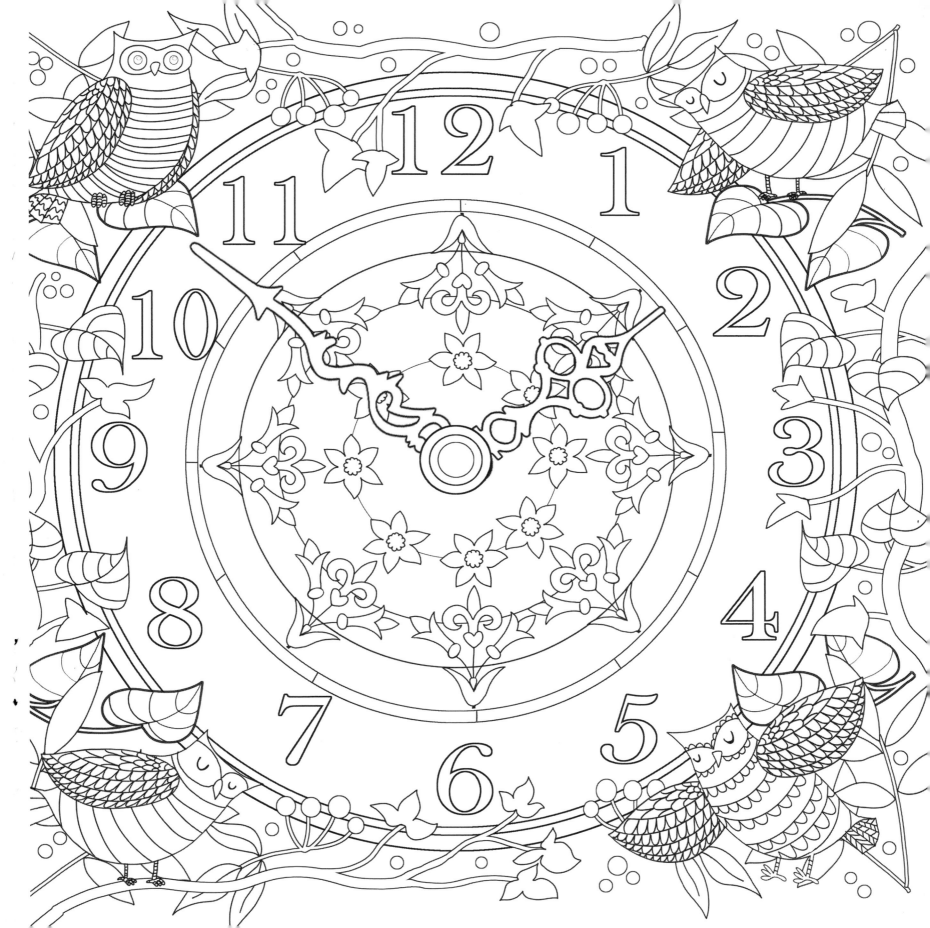

BRIGHT
shining

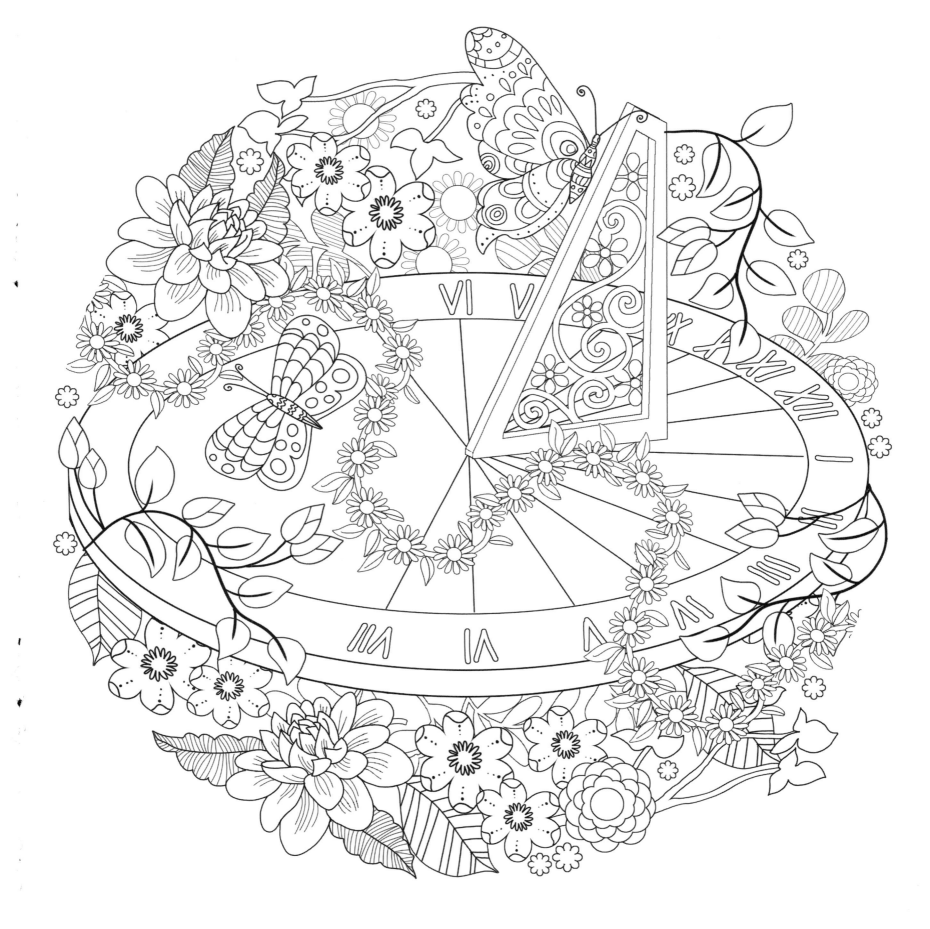

AS
THE
SUN,

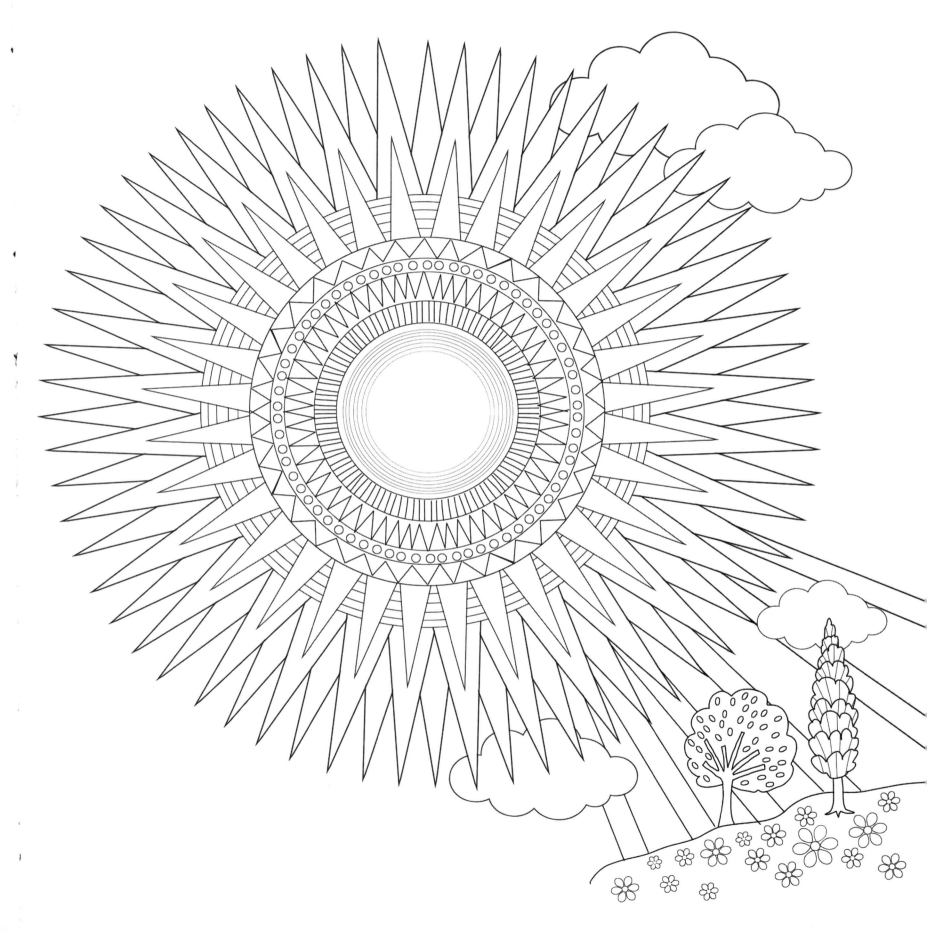

We've no less Days

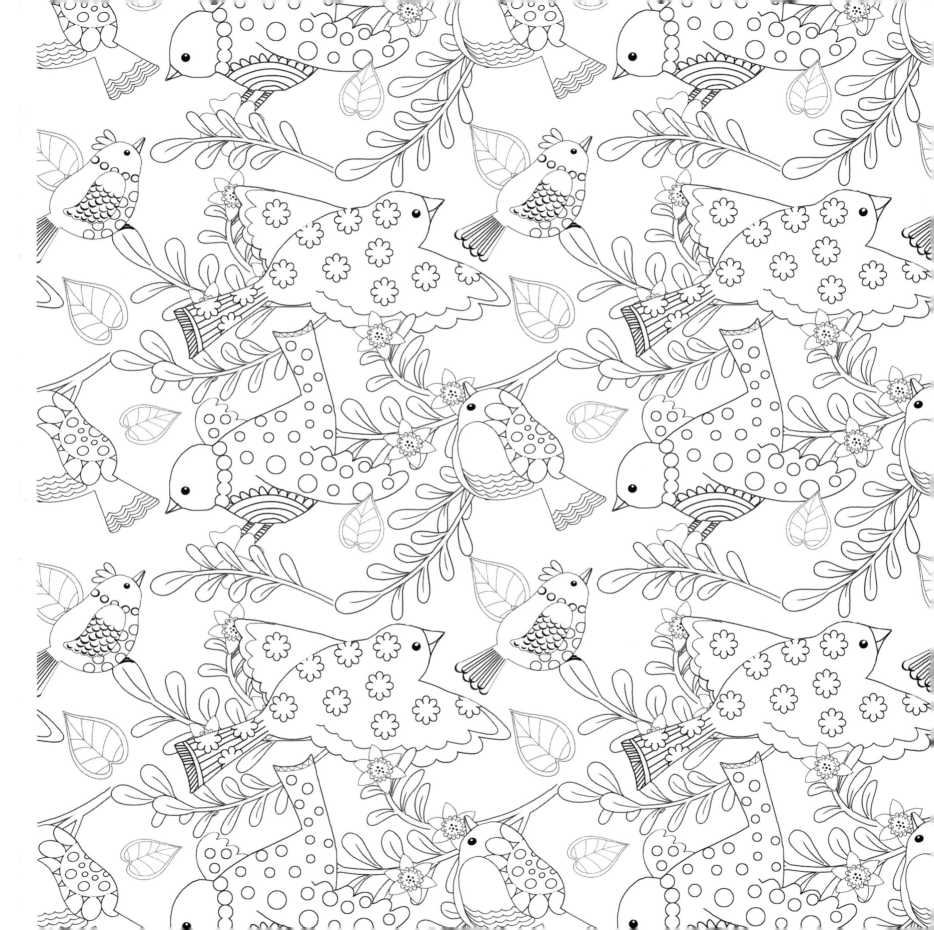

to
SING
God's
PRAISE

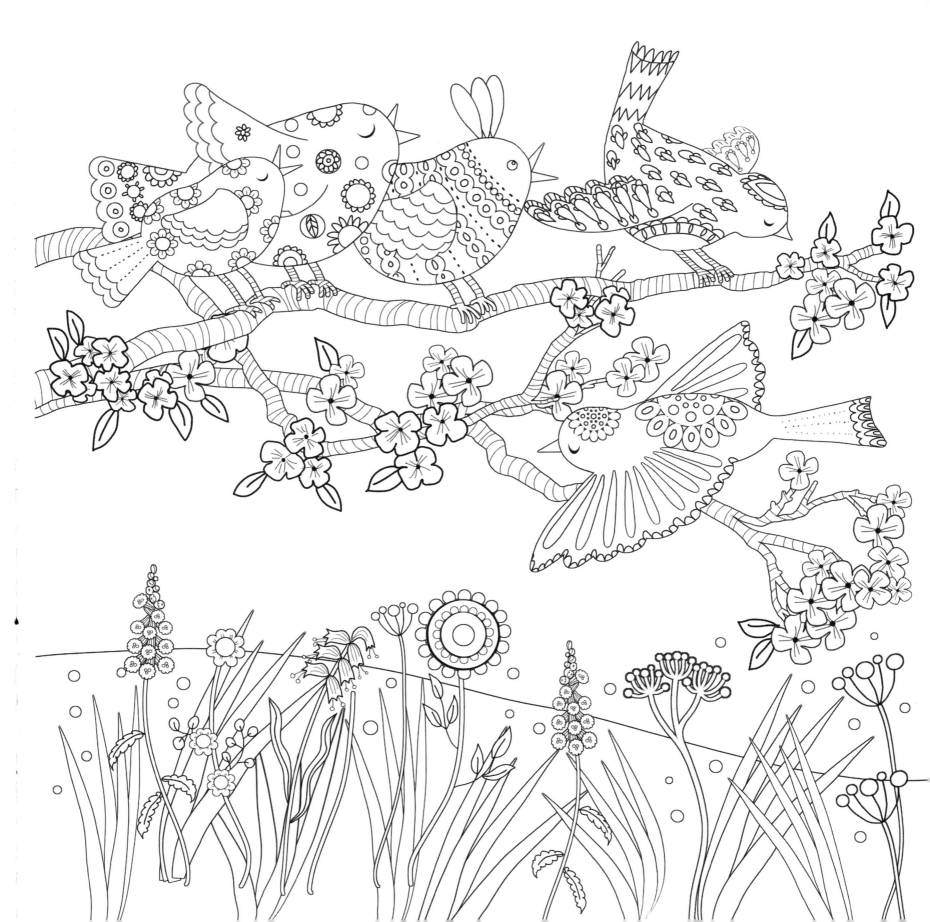

Than when we'd first begun.

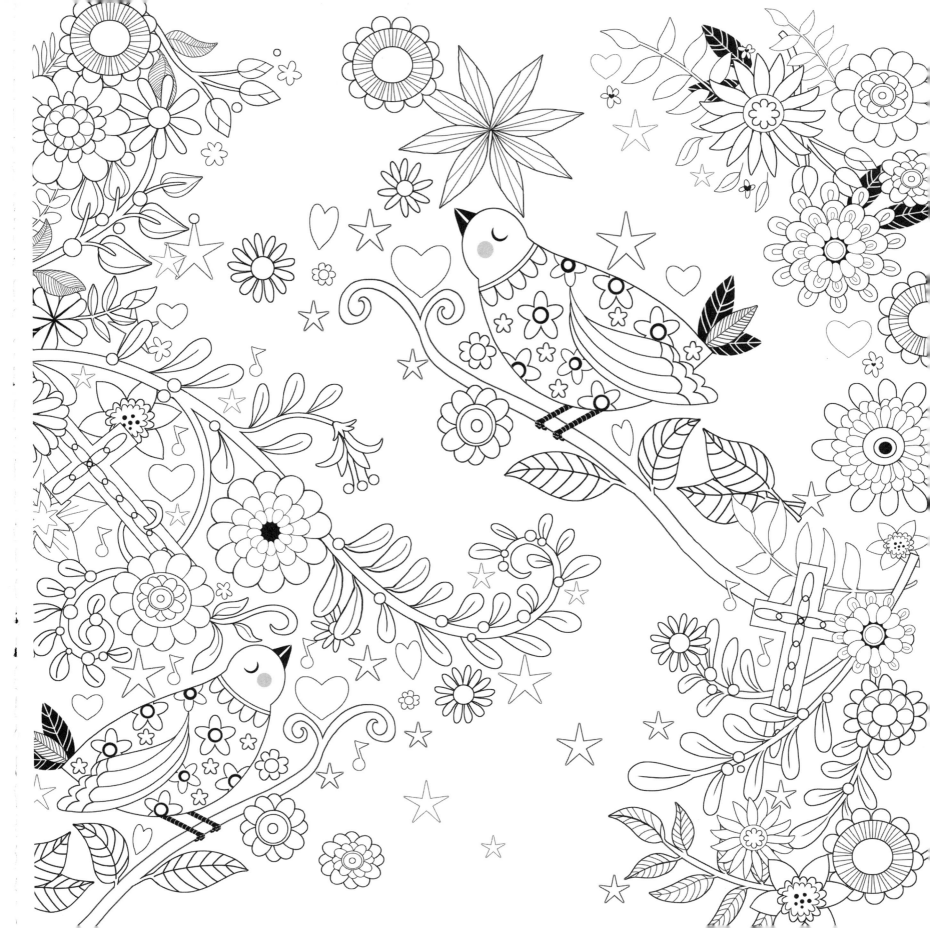